IMAGES
of America

LA QUINTA

D0757156

IMAGES
of America

LA QUINTA

La Quinta Historical Society

ARCADIA
PUBLISHING

Copyright © 2020 by La Quinta Historical Society
ISBN 978-1-4671-0590-3

Published by Arcadia Publishing
Charleston, South Carolina

Printed in the United States of America

Library of Congress Control Number: 2020939651

For all general information, please contact Arcadia Publishing:
Telephone 843-853-2070
Fax 843-853-0044
E-mail sales@arcadiapublishing.com
For customer service and orders:
Toll-Free 1-888-313-2665

Visit us on the Internet at www.arcadiapublishing.com

*Dedicated to the ancient Desert Cahuilla and all who
love history and the place called La Quinta.*

CONTENTS

Acknowledgments 6

Introduction 7

1. The Santa Rosa Mountains and Ancient Lake Cahuilla 9

2. The Cahuilla 15

3. The Bradshaw Trail, Early Settlers, and Point Happy Ranch 27

4. John Marshall Ranch, Point Happy Date Gardens, 39
 and a Horse Named Jadaan

5. The La Quinta Hotel 57

6. Santa Carmelita del Vale and the Desert Club 77

7. Hard Times 87

8. Waterways and Fairways 95

9. The Drive for Incorporation 119

Bibliography 127

ACKNOWLEDGMENTS

We gratefully acknowledge the contributions of the following individuals and organizations: Judy Vossler, Kay Wolff, Harry M. Quinn, Sherry Martinez, the Coachella Valley Water District, the La Quinta Historical Society Board, and the day-to-day contributions of patrons and a supportive community. Unless otherwise noted, all images are from the La Quinta Historical Society archives.

INTRODUCTION

La Quinta, nestled in the beautiful Santa Rosa Mountain range, has a unique history and charm dating back to the ancient Desert Cahuilla, who believed creation originated here. Their cultural heritage included small tribal settlements around a large lake, aptly named Ancient Lake Cahuilla, used for thousands of years to provide shelter, sustenance, and trade.

As early as the mid-17th century, non-native explorers found the area's coves sheltering from the Santa Ana winds, flash flooding, and intense heat; its natural aquifer and soil conducive to raising crops; and its clean air restorative. Word traveled, and early adventurers, homesteaders, and settlers arrived in the early 1900s, including businessman John L. Marshall, oil magnate and philanthropist Chauncey D. Clarke, and Walter H. Morgan, son of wealthy oyster company magnate John S. Morgan.

Marshall built an estate that stands as Hacienda del Gato today. Clarke built a storied ranch, called Point Happy Date Gardens, which is lost to time. Morgan designed and built a spectacular Spanish Colonial Revival hotel in 1926 with famed architect Gordon B. Kaufman. He named it La Quinta after a Spanish term commonly used to refer to a country estate. The hotel is as popular today as when it celebrated its grand public opening on January 29, 1927. It is the source of the city's name.

Morgan wanted his guests to experience luxury. Coming from a wealthy family with connections, he knew how to entice successful businessmen and many Golden Age of Hollywood celebrities to the hotel by providing them what they desired most: privacy. Word spread of the hotel's amenities and the area's charms, providing additional incentives for tourism and growth.

Kaufman designed at least six more architectural gems bordering the hotel property, with names like La Serena and Casa Magnolia (later the villa La Casa), catering to moneyed clients and further promoting the area, increasingly referred to as "La Quinta."

Another developer, E.S. "Harry" Kiener, an executive of the Guild Moccasin Company, purchased several thousand acres around the La Quinta Hotel with the intention of subdividing portions and promoting tourism and settlement. This led to developing the historic Cove area and early commercial business enterprises in the village, along with a park, and the beginnings of a community. Plagued by ill health, Kiener sold his interests to company personnel who would go on to honor his plan to build the fabulous Desert Club of La Quinta. The sleek, Art Moderne structure designed by architect S. Charles Lee, renowned for his theater design on the West Coast, was quite distinct from the Spanish Colonial Revival style and formality of the La Quinta Hotel. Both locations flourished.

Agriculture also played a prominent role in La Quinta's early development, starting primarily with purchased or leased 80- and 160-acre homesteads. Dates were grown profitably by many farmers and ranchers starting in the early 1910s. Many successful date groves financed a larger farm or ranch later on, or enabled the owner to retire early. Other crops also did well with early and year-round growing seasons, eager East Coast markets, and a nearby rail station in Coachella,

California, to transport the crops. The names Burkett, Pedersen, and Kennedy still resonate, although the farms and ranches that made them famous are now long gone, lost to residential and golf course development.

The first golf course in the Coachella Valley was a nine-hole course built at the La Quinta Hotel by Norman MacBeth around 1927. A highly sought-after golf course architect, MacBeth set the standard for course development at the time. His La Quinta course was a harbinger of what was to come, with increasing interest in tourism, golf, and tennis. Aficionados were seeking first-class facilities. The La Quinta Country Club, formed in 1958, along with upgraded Landmark Land Company–designed courses at the La Quinta Hotel (built in the 1980s), provided new venues and challenges. Some of the finest golf and tennis in the world has been played on La Quinta's courses and courts.

La Quinta has always promoted the arts, and the La Quinta Art Foundation incorporated in 1982. Starting small, the inaugural arts festival, Celebration of the Arts, drew 50 artists and 1,476 attendees on the grounds of the Desert Club in 1983, then grew into an internationally-recognized event attended by thousands each year.

Individuals kept the history of the community alive in diaries, official documents, memorabilia, and newspaper clippings until an official historical society was incorporated in 1985. The first president was Alice Bailes Bell. A treasure trove of information and artifacts flowed into the new La Quinta Historical Society Museum, housed in the hexagonal casita built in Harry Kiener days. In 2008, a new City of La Quinta Museum opened, preserving the historic casita on its grounds, which now serves as the office of the La Quinta Historical Society.

Explore these pages and learn how the community of La Quinta, the "Gem of the Desert," began and evolved.

One

THE SANTA ROSA MOUNTAINS AND ANCIENT LAKE CAHUILLA

The spectacular Santa Rosa Mountains are part of the Pacific Peninsular ranges. Located primarily in the La Quinta area, they also extend partially into Imperial and San Diego Counties in California. Relatively short compared to many mountain ranges at just 30 miles in length, the Santa Rosa Mountains exhibit a variety of flora and fauna, including native California fan palms, sand verbena, yuccas, and mesquite, along with peninsular bighorn sheep and many species of smaller animals such as rabbit, bobcat, and quail.

One prominent feature of these mountains dating back several millennia was prehistoric Ancient Lake Cahuilla, sometimes referred to as Lake LeConte or Blake's Sea on early maps. Formed by freshwater flows from the Colorado River in and out of the Salton Sink, geologists estimate the lake periodically reached over 100 miles long, 30 miles wide, and 300 feet deep, making its surface area over six times the size of today's Salton Sea. The lake ran from north of Point Happy in present-day La Quinta to the delta in Imperial County, following a pattern of filling and receding whenever the river changed course over thousands of years. Human habitation along the shoreline dates as far back as 2,500 years, with indigenous peoples' villages, fish traps, petroglyphs, and other artifacts unearthed.

By the time Spanish explorers traversed the area around 1774, the ancient lake had completely evaporated, with only Desert Cahuilla oral histories retaining memories of the great body of water. Travertine limestone deposits, sometimes referred to as tufa, can still be seen along the ancient shoreline.

Another interesting geologic feature near present-day Lake Cahuilla Veterans Regional Park is the Martinez Slide, considered one of the largest rockslides in the United States. Scientists estimate it was likely triggered by a 7.0 magnitude or higher earthquake centered on a nearby peak sometime before 1680. Over 500 million cubic feet of debris were deposited over a three-mile area covering depths of 40–180 feet, with many boulders measuring over 55 feet long and up to 20 feet high.

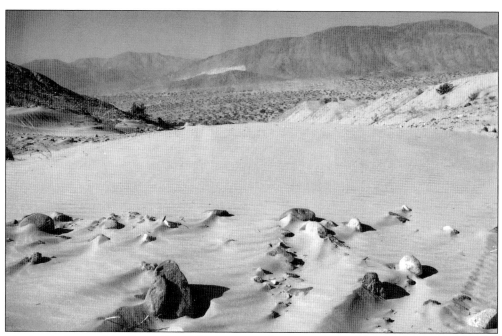

The harsh desert of the Santa Rosa Mountains, with summer heat often exceeding 120 degrees, is tempered by warm winter breezes and fields of springtime wildflowers, as seen here. Such contrasts are part of the natural environment supporting a variety of lifeforms in and around the Santa Rosa Mountains. Previously, this area was part of a large prehistoric freshwater lake, Ancient Lake Cahuilla. The exact date of the lake's formation is unknown, but geologists date much of it to the Holocene and Pleistocene eras, over 26,000 years ago. Ancient Lake Cahuilla, over 100 miles long and 30 miles wide, covered a surface area of over 2,000 miles. Evidence of the shoreline is still visible around the base of the Santa Rosa Mountains near Madison Street and Avenue 58 in La Quinta.

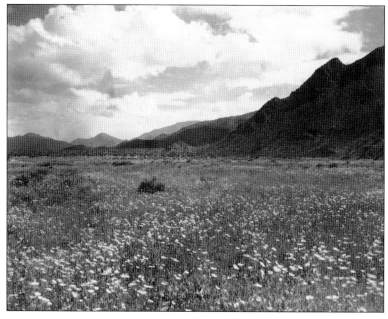

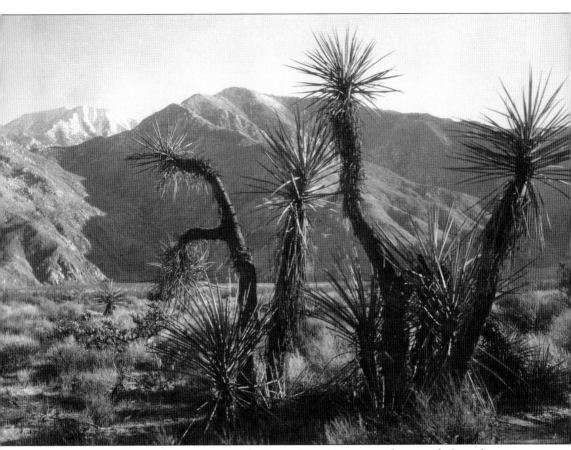

Yuccas fill the foreground in this spectacular Santa Rosa Mountains photograph. In earlier times around Ancient Lake Cahuilla, such plants would have been much less dominant. While the lake provided freshwater fish and mussels, marsh-like plants such as tule, cattails, and bulrushes around the shoreline provided food and tool-making resources for early inhabitants. Excavated areas also show plant materials from the lake's shoreline being used for building enclosures for shelter from weather extremes and periodic flooding by the Colorado River. With the evaporation of Ancient Lake Cahuilla by the 1600s, more drought- and salt-tolerant species such as yuccas, sand verbenas, and agaves began to migrate into the soils left by the ancient lakebed, changing the landscape to the familiar one seen today around the La Quinta area.

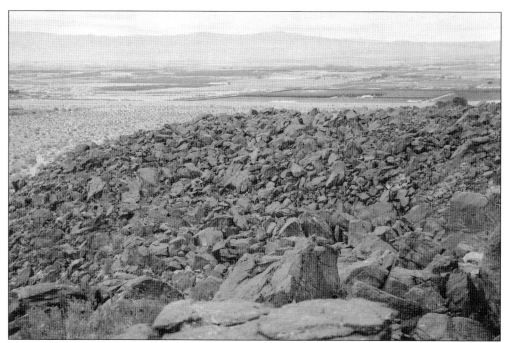

Martinez Slide debris graces the hillsides with its many boulders, rocks, and splinters. Much of the rock is crystalline, so water was probably not a significant factor in triggering the slide. Geologists think that major seismic events hundreds of years ago caused the slide and provided the energy needed to break the rocks apart and start them moving. Archeologists believe the boulders provided shelter, workspaces, and cache basins for early inhabitants. Past excavations revealed pottery sherds, shell beads, milling stone fragments, and arrow points. The area is very popular for hiking and exploring and can be seen south of Avenue 60 in La Quinta.

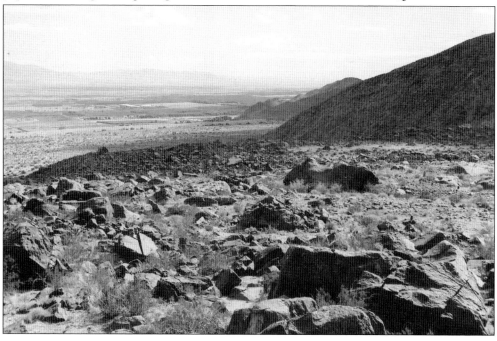

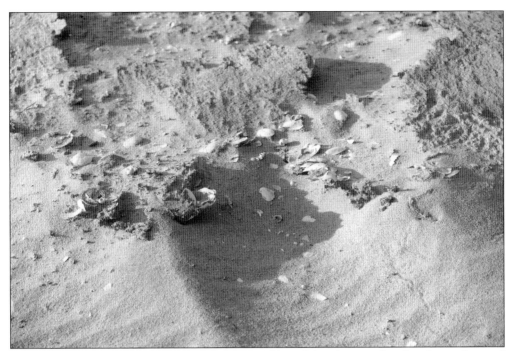

Sand-encrusted freshwater mussel shells are pictured here. Mussels were often found in and around early villages of Ancient Lake Cahuilla. They provided food, along with several varieties of fish, small animals, and birds for the inhabitants of the communities around the lake. Many of the shells from mussels and other aquatic life were made into tools.

Wave action against the mountain bedrock in ancient times left travertine (or tufa as it is referred to locally) deposits on the slopes. Freshwater limestone deposits, pictured here, contain high concentrations of calcium carbonate and appear as light-colored features along the base of the Santa Rosa Mountains.

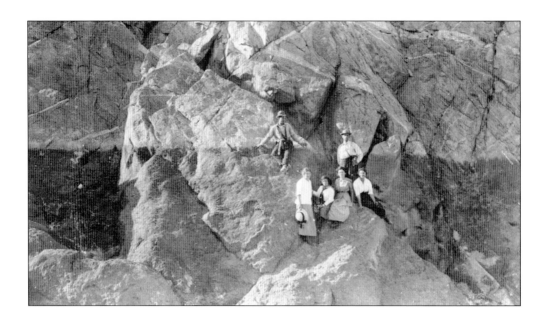

A group takes a break and enjoys a stop among travertine deposits left over from the evaporation of Ancient Lake Cahuilla hundreds of years ago. The characteristic "bath tub ring" remains a familiar sight, prominently seen near Madison Street and Avenue 58 in La Quinta, and is a testament to the longevity of these freshwater calcium carbonate limestone deposits. Excavated sediments from the old lakebed reveal a fascinating array of freshwater aquatic life, including mollusks and mussels, diatoms, several species of fish and birds, and plant and pollen specimens. (Both, courtesy of the Coachella Valley Water District.)

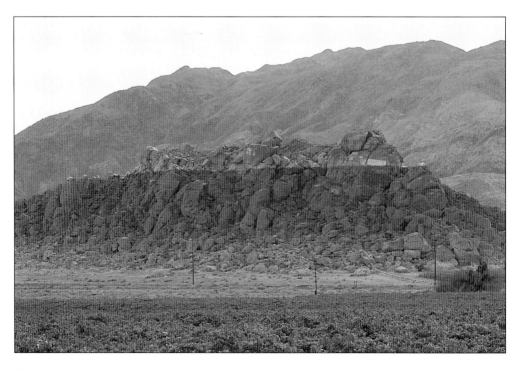

Two

THE CAHUILLA

The Cahuilla were indigenous people residing in inland portions of Southern California for over two millennia. Three distinct Cahuilla divisions emerged over time—Mountain, Pass, and Desert. The Desert Cahuilla lived in approximately 20 villages in the lower Coachella Valley, encompassing the present-day La Quinta area and eastward. Many small encampments were created around Ancient Lake Cahuilla, as the lake provided both plant and small-game resources for the hunter-gatherer society. Two especially important resources were mesquite and native fan palms. Their fruit was harvested annually by Cahuilla women and stored in granaries for later use or ground into mash for cakes using mortars. The cakes could also be dried for storage.

The Cahuilla dug wells for water, calling them te-ma-ka-wo-mal, or "earth ollas," often using pottery bowls and digging sticks to dig them by hand to depths of 15 feet or more. Wells often became sites for villages or Cahuilla subbranches called nets or "sibs." The La Quinta area had two well sites, one near Highway 111 and Washington Street near Point Happy, known as Kavinish, and one in the area of the Cove called Kotevewit, close to Tradition Golf Club.

Incorporating natural fibers, materials, and advanced weaving techniques, the Cahuilla were exquisite basket makers. Examples of these were captured by early photographers Edward S. Curtis and George Wharton James around 1899–1926.

The Cahuilla traded with various tribes but had little contact with non-native explorers before Juan Bautista de Anza's expedition in 1774. Later expeditions resulted in the Cahuilla losing large tracts of tribal lands and surrendering control to the Spanish. When Mexico secured independence from Spain in 1821, the Cahuilla fared little better under their control.

Upon the conclusion of the Mexican-American War and the signing of the Treaty of Guadalupe Hidalgo in 1848, Mexico formally ceded California to the United States, whereupon a number of reservations and initiatives were created to relocate indigenous peoples, with their overall condition not improving greatly. The Desert Cahuilla were assigned to the Torres-Martinez Reservation, established in 1876, which remains active today.

The descendants of early Desert Cahuilla continue to work and thrive in the desert communities, sharing their culture and traditions with all.

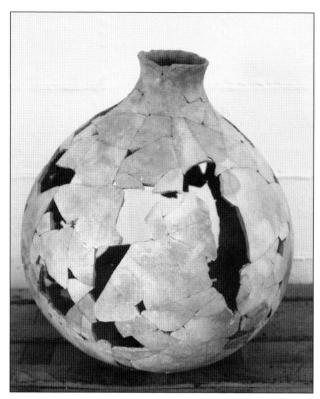

Pictured here are two ollas, sometimes referred to as pots or jars. Ollas were frequently used by Desert Cahuilla for gathering and storing water from local wells. Other uses included cooking, seed storage, and irrigation. They were typically made from unglazed clay with a narrow neck to help slow evaporation. The partially reconstructed olla at left is the work of Tom Kennedy, from pottery sherds found on the Kennedy Brothers Ranch, while the other olla was originally found in the southern section of the Anza-Borrego area, within the Desert Cahuilla territory.

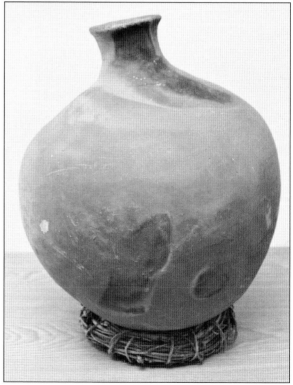

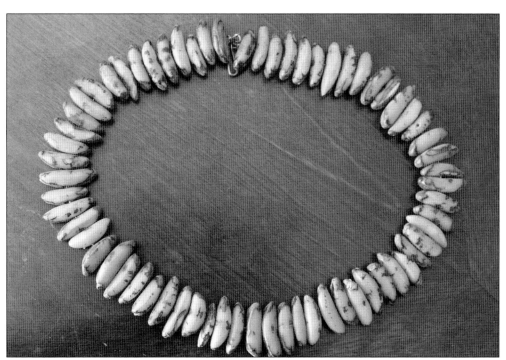

Pictured is a date-pit necklace. Desert Cahuilla used the fruit and fibers from native desert fan palms (*Washingtonia filifera*) as foodstuffs and for basket and roofing materials, and as decorative items for individual use or trade. Shell beads were also commonly used as currency in trade.

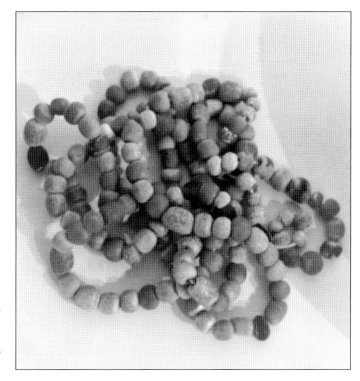

This blue stone bead necklace consists of glass fragments, porous stone, and possibly pumice, most likely collected around the area and used as decoration or in trade. A hand-driven drill bit or bone awl was used to make small holes to string the beads together.

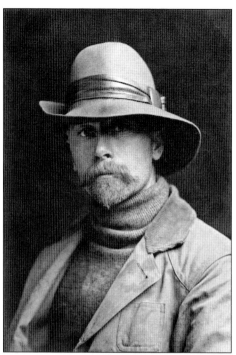

Here is a c. 1889 self-portrait of young Edward S. Curtis (1868–1952), a famed American photographer and ethnologist. Curtis is noted for his attention to detail and photographic style. He took thousands of scenes of the American West, including photographs of Desert Cahuilla women around 1905 and a type of Desert Cahuilla living structure, a kish, around 1924. Such scenes would have been familiar around Desert Cahuilla villages, including the historic Cove area of La Quinta. At one time, eight of Curtis's Desert Cahuilla prints were displayed at the La Quinta Hotel and were later donated to the La Quinta Historical Society. (Courtesy of Library of Congress.)

Photographer George Wharton James (1858–1923) is pictured here. His work captured lifestyles of various indigenous peoples, including the Cahuilla, during the early 20th century. (Courtesy of Doheny Memorial Library, University of Southern California.)

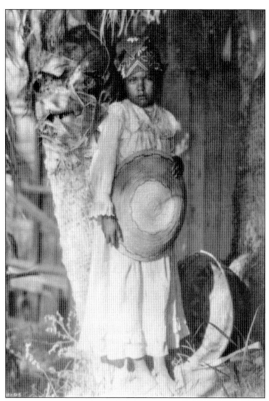

These two Edward S. Curtis photographs are titled "A Desert Cahuilla Child" (right) and "The Harvester." Both were captured using glass-plate negatives in 1905 and reflect aspects of everyday life in a Cahuilla village. Cahuilla women would gather seeds and fruits at harvest time for storage in large basket granaries and ollas. Mesquite seed pods were also used in cakes and stews after being ground with rock mortars. Cahuilla children would learn these traditions at an early age from parents, older siblings, and other tribal members who passed them down from generation to generation. (Both, courtesy of Library of Congress.)

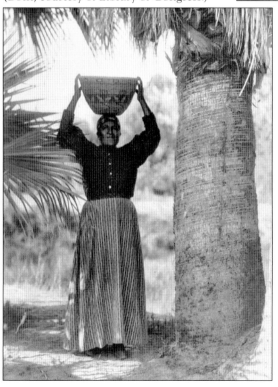

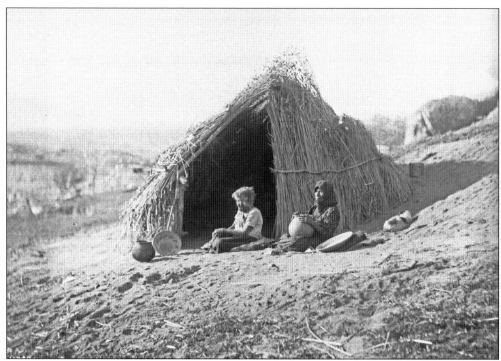

These two Edward S. Curtis photographs, both titled "The Kish," were taken in 1924 using glass-plate negatives. A kish could be constructed of various materials, including native fan palm fronds, arrowweed plants, or brush covering wooden poles. They were often referred to as "brush houses." Some had a complete opening in the front, as seen above, while others were rounded and enclosed, as shown below. The kish provided shelter from the extremely hot summers in the Desert Cahuilla environs and were used primarily for sleeping, with socializing, cooking, and activities such as basket-making occurring outside. (Both, courtesy of Library of Congress.)

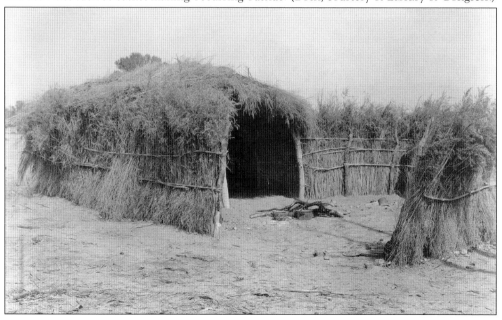

The photograph at right was taken in 1926 by Edward S. Curtis and is titled "Desert Cahuilla Woman." The photograph below was taken by George Wharton James in 1903 and is titled "Agua Caliente Woman, Nievas Chaves, with a Metate Stone." She is grinding grain with her four children present and is the daughter of Simon and Sensioni Cibinoat. The Agua Caliente Reservation in Palm Springs, California, home of the Pass Cahuilla, was relatively close to the Desert Cahuilla and the Torres-Martinez Reservation. Their daily activities would have been similar. (Right, courtesy of Library of Congress; below, courtesy of California Historical Society; University of Southern California Libraries Special Collections.)

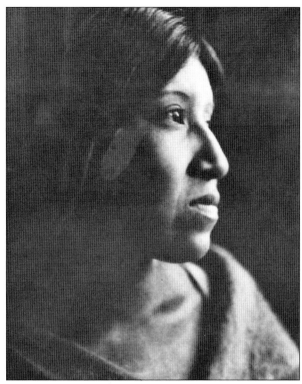

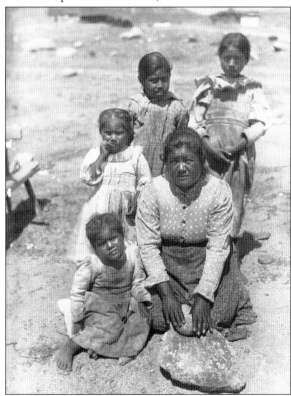

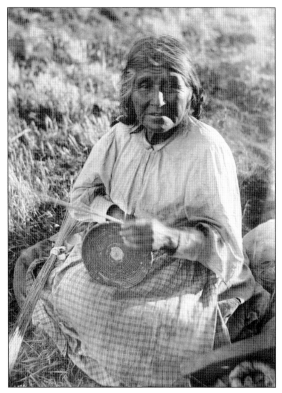

The photograph at left, taken by George Wharton James, shows the famous Cahuilla basket maker Maria Los Angeles around 1900. Cahuilla basket makers only made coiled baskets, weaving the coils counterclockwise starting from the bottom. The c. 1900 photograph below, also taken by James, shows another famous Cahuilla basket maker, Mercedes Nolasquez, a Pass Cahuilla from the nearby Agua Caliente Reservation. Weaving a basket could take a few hours to several months. Weavers often sat on the ground, working with softened plant materials and an awl made from animal bone. (Both, courtesy of Doheny Memorial Library, University of Southern California.)

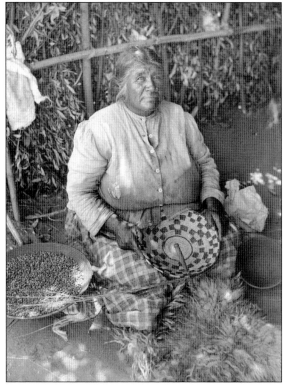

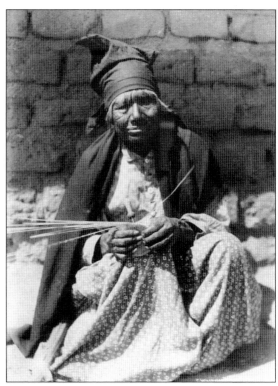

These photographs are the work of lecturer and photographer George Wharton James. The one at right shows well known Cahuilla basket maker Maria Antonia at work around 1900, while the photograph below shows Maria Casseri, another celebrated Cahuilla basket maker whom James photographed around 1899. The Cahuilla were highly regarded for their intricate coiled baskets and unique designs, which were eagerly sought by travelers through the region in the late 1800s and early 1900s. (Both, courtesy of Doheny Memorial Library, University of Southern California.)

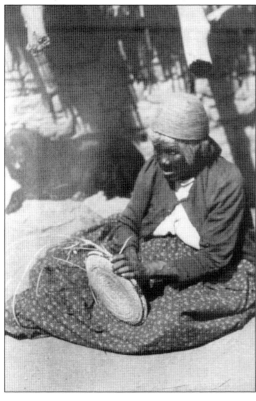

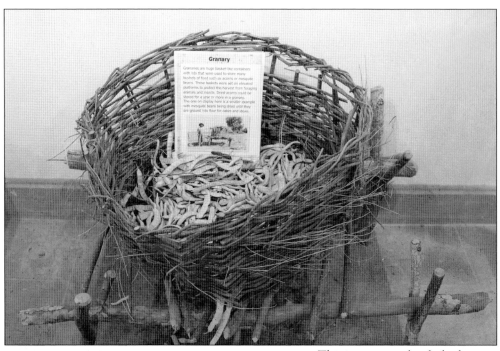

Granary

Granaries are huge basket-like containers with lids that were used to store many bushels of food such as acorns or mesquite beans. These baskets were set on elevated platforms to protect the harvest from foraging animals and insects. Dried acorns could be stored for a year or more in a granary. The one on display here is a smaller example with mesquite beans being dried until they are ground into flour for cakes and stews.

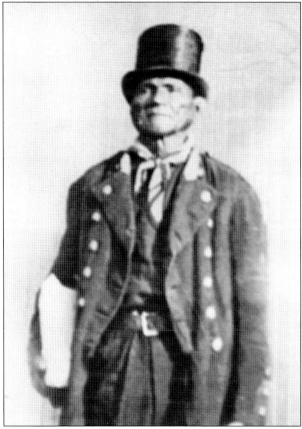

This is an example of a basket granary. The Cahuilla used large basket granaries set on poles for storing mesquite seed pods, screw beans, and other foodstuffs, while other seeds, dried fruits, and raw materials were stored in ollas. Both provided critically important resources if a drought or flood occurred. Fruits, blossoms, and buds were dried in the sun to preserve them. Plants and seeds were preserved by sealing the granaries with pitch or sap.

Fig Tree John, the well-known Cahuilla leader of the Torres-Martinez Tribal Council during the 1920s, is pictured here. His actual name was Juanita Razon. He is rumored to have planted the first fig trees in the Coachella Valley. His age has always been in dispute, with some claiming him to be 135 years old at the time of his death in April 1927. (Courtesy of Banning Library District.)

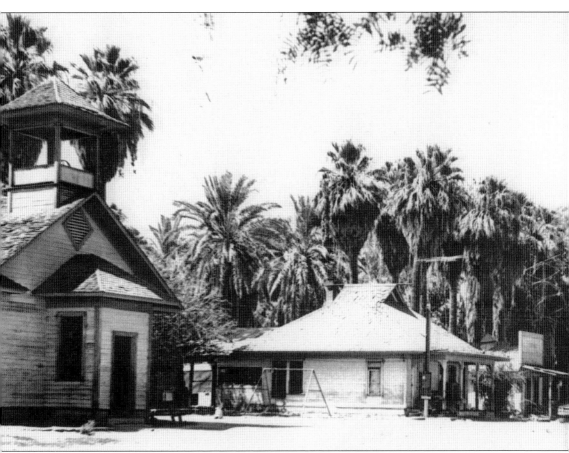

Three clapboard buildings are pictured at the Torres-Martinez Indian Reservation south of Thermal, California. The reservation was established by the US government in 1876 and still exists today. The Desert Cahuilla, including those from the La Quinta area, were assimilated into the Torres-Martinez Reservation at this time. Some Cahuilla came from locations marked as "rancherias" on earlier maps, while others had lost their ancestral lands over many years to encroaching non-native settlers and development. The original reservation buildings were constructed in 1907 and consisted of, from left to right, the Martinez Indian School, a residence, and the Martinez Indian School and agency office. They are considered the oldest standing Indian Agency buildings in California and, on May 17, 1973, were listed in the National Register of Historic Places in the Martinez Historical District as well as being designated a California point of historical interest.

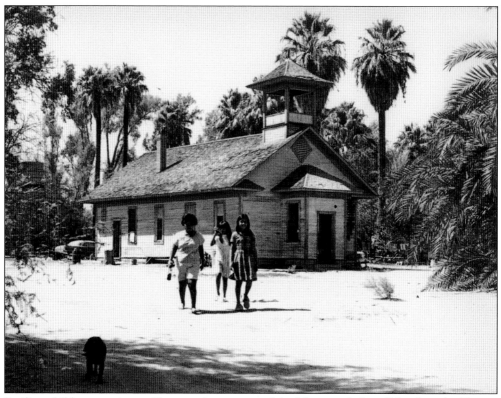

Smiling children are pictured leaving the vicinity of the Martinez Indian School on the Torres-Martinez Reservation accompanied by their friendly dog. The school provided educational needs for local Desert Cahuilla children who previously had to travel over poorly maintained dirt roads to Thermal, eight miles away, to attend school. The one-room schoolhouse and a small residence for a teacher or Indian agent were completed on August 12, 1907. The schoolhouse also functioned as a center for tribal activities.

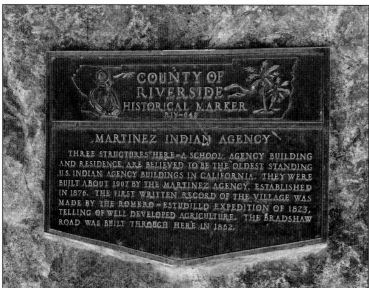

This historical marker was placed by Riverside County. The historical buildings were being restored at the time the photograph was taken in 2015. (Courtesy of Sherry Martinez.)

Three

THE BRADSHAW TRAIL, EARLY SETTLERS, AND POINT HAPPY RANCH

Major events transpired to promote non-native growth around the La Quinta area, then more widely known as the Santa Rosa Cove area. Knowledge of the primary Cahuilla route across the Colorado Desert was relayed to experienced guide William David Bradshaw's party in May 1862 by Chief Cabazon (also sometimes spelled Cabezon), the appointed head of the Desert Cahuilla. Early explorers, and especially those seeking quick routes to the goldfields around the Colorado River near La Paz County, Arizona, used the route and referred to it as the Bradshaw Trail. By September 1862, the trail provided many pack and freight wagon expeditions, along with the Colorado Stage and Express Line, a stop at the site of ancient Cahuilla wells and close proximity to Norman "Happy" Lunbeck's store and stable in the Santa Rosa Cove area, which became known as Point Happy Ranch.

Pres. Abraham Lincoln signed the Homestead Act on May 20, 1862, granting all US citizens, and immigrants intending to become naturalized citizens, 21 years of age or older 160-acre land patents in exchange for improvements on the land, growing crops, residing on the property for five years, and paying a small filing fee. Much of the land was tribal territory ceded to the US government via treaties, or other lands, such as those surrendered to the government at the end of the Mexican-American War in 1848. Affected Desert Cahuilla communities became affiliated with the Torres-Martinez Reservation, which began in 1876.

On March 3, 1877, Congress passed the Desert Land Act, also referred to as the Desert Land Entry Act, essentially amending the Homestead Act of 1862. Both acts promoted development, irrigation, and reclamation of arid lands in the West, such as Norman Lunbeck's Point Happy Ranch, which his widow, Anna, later filed for homestead status in the early 1900s.

Approximately 10 months earlier, on May 29, 1876, the Southern Pacific Railroad began the first scheduled passenger, mail, and freight service between Los Angeles and Indio, California. This further encouraged ranchers and commercial entrepreneurs to settle and homestead in the area, along with a growing number of tourists visiting the beautiful Santa Rosa Mountains.

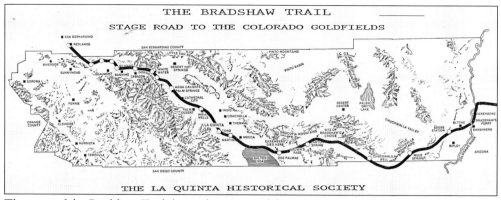

This map of the Bradshaw Trail shows the extent of the stage road from Redlands, California, in San Bernardino County to the Colorado River goldfields near La Paz County, Arizona. The trail was used extensively from 1862 to 1877 until the goldfields played out and travel by rail became increasingly popular.

The Bradshaw Stage

Early members of the La Quinta Historical Society incorporated a graphic of the Bradshaw Stage on their stationery for a number of years in tribute to the entrepreneurial spirit displayed by early pioneers traveling across the dangerous and hostile Colorado Desert via the stage.

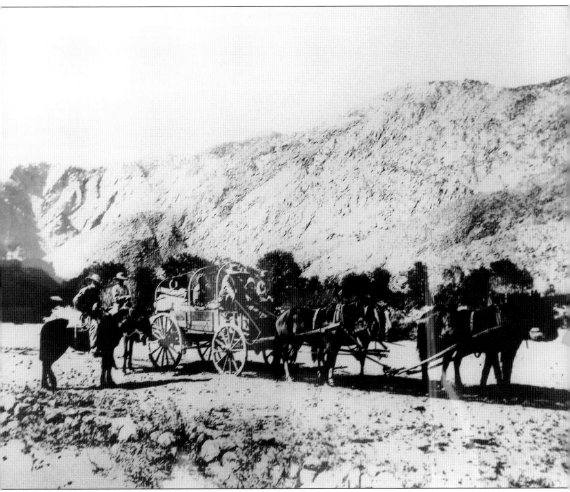

Early travelers through the Coachella Valley found it to be hot, dusty, and hard, especially in the summer, and only slightly less strenuous in the winter. In 1862, the availability of water, always a concern, led the guide William Bradshaw and his party to find the natural springs and water holes across the Colorado Desert as relayed by Chief Cabazon, to sustain the growing number of Californios and migrants traveling through the area. Wagons broke down frequently due to the roughness of the trail. Accidents and illness claimed some, while inclement weather sidelined parties and the stage line from time to time. The Santa Rosa Mountains often provided protection and shelter from devastating sandstorms, extreme temperatures, and flash floods.

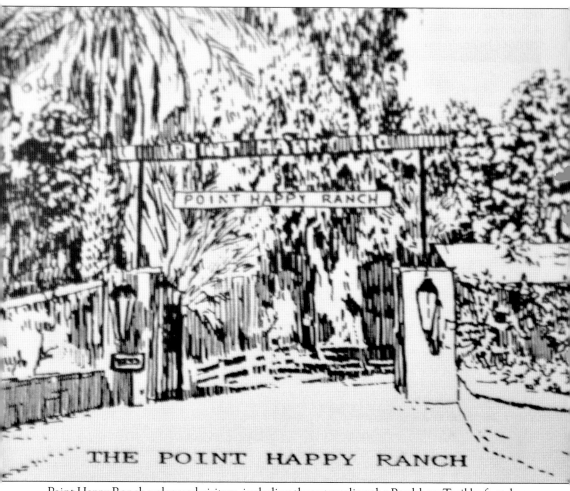

THE POINT HAPPY RANCH

Point Happy Ranch welcomed visitors, including those traveling the Bradshaw Trail by foot, horse, or wagon or riding the stage line. Owner and operator Norman "Happy" Lunbeck had the good fortune to locate his Point Happy Ranch store, trading post, and stable close to where a number of activities and people met—prospectors, trappers, traders, Desert Cahuilla and other indigenous tribes, along with early explorers. As the area grew in population, the first Point Happy School, a one-room elementary school, was built on Point Happy Ranch to help educate the growing number of children of the first settlers in the Santa Rosa Cove area. This sketch of Point Happy Ranch was drawn around 1950.

Pictured are the legal entries of Norman "Happy" Lunbeck's activities, beginning in 1907, leading up to filing for homestead status on 160 acres comprising the Point Happy Ranch in Santa Rosa Cove. Having fulfilled all the requirements, including the five-year residency, homestead status was awarded on May 14, 1913, by the register of the General Land Office in Los Angeles, California, to Anna, Lunbeck's widow.

The land patent document delivered in person on June 2, 1913, carried Pres. Woodrow Wilson's signature. Before 1833, it was a requirement that land patent certificates be personally signed by the president of the United States before being issued, but in 1833, the process changed to the president's name written on every land patent by an authorized secretary or executive clerk. The president's signature was eliminated entirely from the process in 1948.

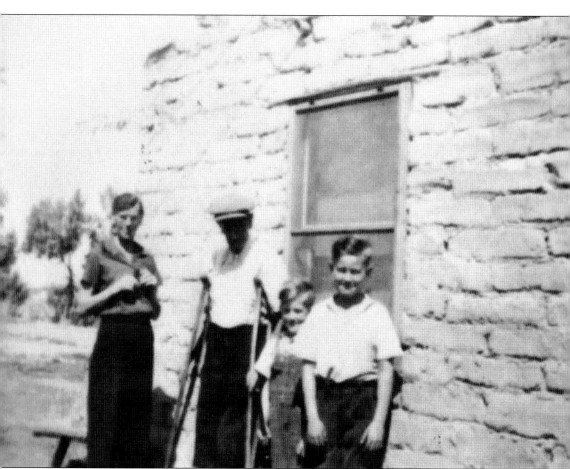

Pictured is Manning Burkett (second from left) with Lottie and grandsons Bill and Jack. Settlers like Burkett came to the Santa Rosa Cove area in the early 1900s. He moved his family from Maine to Long Beach, California, finally relocating to the Santa Rosa Cove area due to his son's asthma. He bought land for 25¢ an acre and applied for homestead status in 1907. He built a windmill for water, planted row crops and alfalfa, and maintained a string of horses. He was a carpenter by trade and worked for Walter H. Morgan for a time at the La Quinta Hotel and Chauncey D. Clarke at Point Happy Date Gardens, building stables for the Arabian horses. While there, he stubbed his toe, which ultimately became gangrenous and had to be amputated. He continued to work on crutches.

El Centro 01870

4—1003-R.

The United States of America,

To all to whom these presents shall come, Greeting:

WHEREAS, a Certificate of the Register of the Land Office at **El Centro, California,**

has been deposited in the General Land Office, whereby it appears that, pursuant to the Act of Congress of May 20, 1862,

"To Secure Homesteads to Actual Settlers on the Public Domain," and the acts supplemental thereto, the claim of

Manning J. Burkett

has been established and duly consummated, in conformity to law, for the **north half of the southeast quarter**

of Section thirty in Township five south of Range seven east of the San

Bernardino Meridian, California, containing eighty acres,

according to the Official Plat of the Survey of the said Land, returned to the GENERAL LAND OFFICE by the Surveyor-General:

NOW KNOW YE, That there is, therefore, granted by the UNITED STATES unto the said claimant the tract of Land above described; TO HAVE AND TO HOLD the said tract of Land, with the appurtenances thereof, unto the said claimant and to the heirs and assigns of the said claimant forever; subject to any vested and accrued water rights for mining, agricultural, manufacturing, or other purposes, and rights to ditches and reservoirs used in connection with such water rights, as may be recognized and acknowledged by the local customs, laws, and decisions of courts; and there is reserved from the lands hereby granted, a right of way thereon for ditches or canals constructed by the authority of the United States.

IN TESTIMONY WHEREOF, I, **Woodrow Wilson**

President of the United States of America, have caused these letters to be made

Patent, and the seal of the General Land Office to be hereunto affixed.

GIVEN under my hand, at the City of Washington, the **FIFTH**

(SEAL.) day of **JULY** in the year of our Lord one thousand

nine hundred and **SEVENTEEN** and of the Independence of the

United States the one hundred and **FORTY-SECOND**

By the President: *Woodrow Wilson*

By *E. D. Bouldin, Assistant* , Secretary.

S. D. Lamar

Recorder of the General Land Office.

RECORD OF PATENTS: Patent Number **590816** 6—917?

The Manning J. Burkett homestead land patent certificate was awarded in 1917. Sometimes, homestead land patents would lag far behind filings for years due to the sheer volume of applications. The Burkett Ranch operated through five generations of Burketts. The ranch was just north of the Raymond A. Pedersen Ranch on Washington Street in La Quinta. The original ranch buildings were torn down in 1996 and, with them, a slice of homesteading history. The ranch property eventually became Lake La Quinta, a gated residential development.

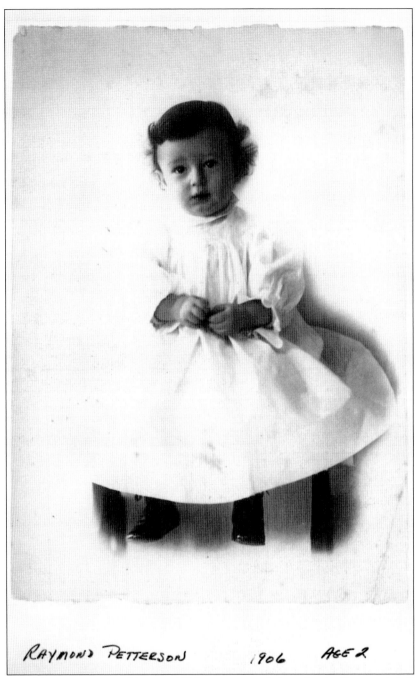

RAYMOND PETTERSON 1906 AGE 2

The Raymond Petterson pictured here in 1906 at age two is believed to be Raymond A. Pedersen, who purchased land in 1929 and 1930 for 25¢ an acre just south of the Manning Burkett Ranch on Washington Street, present-day Lake La Quinta. He married his wife, Olive, in 1930 and was a contractor by trade. He did some work for Walter H. Morgan on the La Quinta Hotel and also built casitas in the Cove. East of the Pederson Ranch, he built a home for Zane Grey. The Pedersons also owned property near the La Quinta Hotel. The land was not cultivatable due to a high clay content but worked out well as landing strips for La Quinta Hotel guests arriving by plane.

These photographs show the fields of the Pedersen Ranch being prepared and harvested. Farming at the ranch consisted of raising beef and pork, along with alfalfa, gladiolas, and vegetable crops. Originally, dates were also grown. In 1941, Pedersen leased his property to Tranquilino "Frank" Hernandez, an employee who lived on the property. Hernandez grew "truck" vegetables until 1944. Later, the Pedersens experimented with growing gladiolas on the property. They were found to adapt well to desert soils and heat, something the ranch had in abundance, and could be grown in different colors.

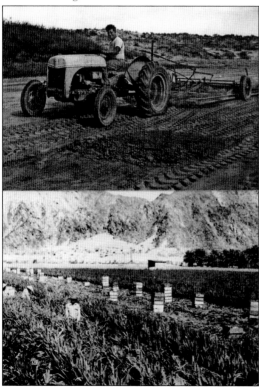

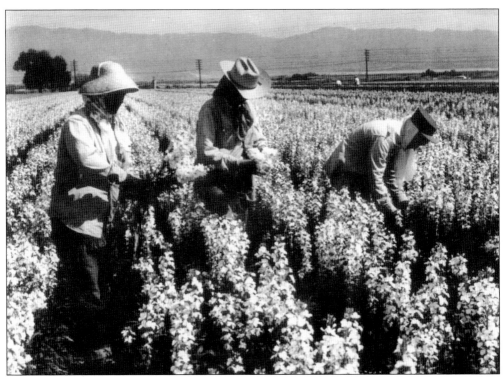

These c. 1950s photographs show field workers Raymond Jr. and his mother, Olive Pedersen, in their gladiola fields. Three sets of fields are shown, each displaying a different color of gladiola. They are harvesting the gladiolas by hand, which will be sent to markets in Los Angeles for distribution. Several crops a year could be harvested. Hours in the sun planting or harvesting necessitated hats and light-colored clothing to reflect as much sunlight as possible. The Pedersens lived at the ranch and raised gladiolas until they relocated to Fallbrook in 1978.

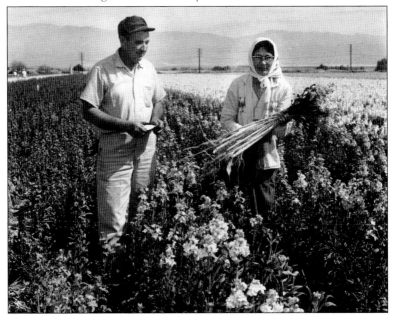

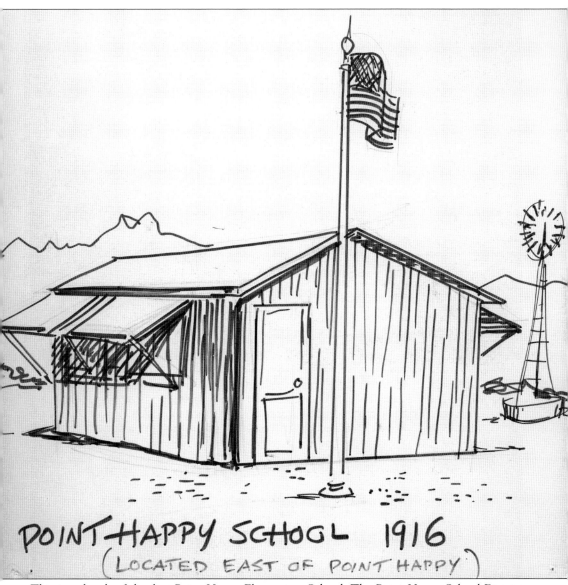

POINT HAPPY SCHOOL 1916
(LOCATED EAST OF POINT HAPPY)

This is a sketch of the first Point Happy Elementary School. The Point Happy School District was formed in 1892 to help with the educational needs of early settlers' and ranchers' children. It is believed to be the first Coachella Valley public elementary school and was built on Norman "Happy" Lunbeck's property in the area known as Santa Rosa Cove. Records show a 1916 student population of four boys and five girls in the one-room schoolhouse taught by state-certificated teacher Bessie E. Darmes. She received a salary of $440 for a 160-day school year, and taught on average seven pupils daily. The largest classes were in grades two and seven, with three students in each. The Point Happy Elementary School was eventually moved a short distance to the west.

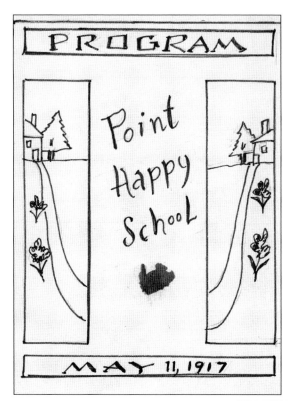

A program is pictured from the Point Happy Elementary School dated May 11, 1917, with handwritten entries outlining the activities for the day. Now-prominent local family names are listed throughout the program. The event was held on a Friday at 2:00 p.m. as the closing exercise for the school year, and attendance was by invitation. A May Day play and maypole dance were performed by the students, and booklets were prepared by the students for Mother's Day and presented to those in attendance. Many of the songs performed were patriotic in nature.

— Program —
1. May Day Play.
2. Hats Off — Allan Longaker.
3. We are the men of the comming Years. — { Herbert Darms { Robert Longaker
4. America the Beautiful — Song by The School
5. When Some Fellows Daddy kills Some Fellows Dad — William Cooky.
6. The Pine { Marjorie Longaker { Shirley Eastman.
7. Unawares — Veryl Eastman
8. The Daisies The Woodpecker { The School
9.
10. Stars of a Summer Night — Sextette.
11. May Pole Dance.
12. Mother's Day Booklets Presented Song Carnations Bring

Four

JOHN MARSHALL RANCH, POINT HAPPY DATE GARDENS, AND A HORSE NAMED JADAAN

In 1902, brothers-in-law John Marshall and Albert Green, paint manufacturers and retailers from Los Angeles, homesteaded property along Avenue 52 in La Quinta. The road leading to the site became known as Marshall Road, sometimes referred to as Marshall Street, developing into the south terminus of present-day Washington Street in La Quinta, where Tradition Golf Club is located. Green sold his property, while Marshall cleared land and built a small house. Later, Al Lopez, a former ranch foreman, recounted that Marshall sought the services of a Mr. Swanson, an architect, for erecting a spectacular Spanish Colonial Revival main house, around 1920, surrounded by exotic desert plants. The area around the ranch was known as Marshall's Cove.

At some point, Marshall moved to Indio, purchased the Indio water system, and collected rents. He still traveled to the ranch frequently in his Ford. He succumbed to a well cave-in on the property in 1938, and his son Harry sold the property to William Starke Rosecrans, a wealthy Los Angeles real estate developer and oil businessman. Rosecrans renamed the ranch Hacienda del Gato after a small gray cat saved his wife, Elizabeth, from a rattlesnake strike at the main house.

Another entrepreneur and philanthropist, Chauncey D. Clarke, and his wife, Marie Rankin Clarke, purchased Point Happy Ranch from Norman "Lucky" Lunbeck's widow, Anna, in 1922. They bought additional properties and renamed the site Point Happy Date Gardens. An avid date grower, Clarke marketed some of the first Deglet Noor dates in California.

A 3,000-square-foot home was built along with two swimming pools, lush date gardens, and guest and servant accommodations. Homes for eight Mexican and Japanese families tending the gardens and ranch operations were built. Marie Clarke was often referred to as "Madame Happy." Keenly interested in Arabian horses, Chauncey Clarke brought 11 purebred Arabians to the ranch, including Jadaan, the legendary gray stallion Rudolph Valentino rode in silent-era films. Chauncey Clarke became seriously ill and sold the Arabians to the W.K. Kellogg Ranch in Pomona, California, a short time before his death in August 1926.

Marie Clarke remained at the ranch until her death in 1948 and was active in the community.

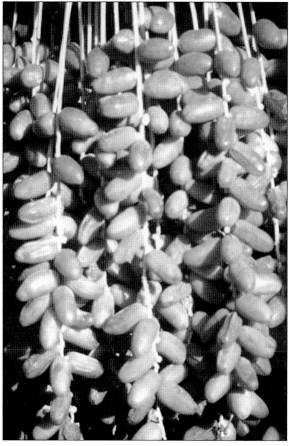

This is an early view of Marshall Road, sometimes called Marshall Street, now known as Washington Street in La Quinta. Marshall Road became a main wagon and car thoroughfare with ranching enterprises on both sides of the road, including the five-generation Manning Burkett Ranch, homesteaded in 1907, one mile south of Highway 111 and Washington Street in La Quinta. The ranch buildings were demolished in 1996, and the property was developed as Lake La Quinta.

The successful growing of imported date shoots from the Middle East by the US Department of Agriculture Date Experimental Station near Mecca, California, in 1904 and at Indio in 1907 provided a new revenue source alongside citrus and row crops. Ranchers planted date groves, including the Marshall Ranch, as the dates readily adapted to the desert soil and could be shipped to markets via the Southern Pacific Railroad siding in nearby Coachella.

Pictured are certificates of register for land patents awarded to John L. Marshall and Albert P. Green on April 10 and May 6, 1914, respectively. Land patents were awarded by the US government to applicants after fulfilling homesteading requirements or purchasing and registering tracts of land available in the public domain. A feature near the homesteads often referred to was the Marshall/Green Lake, where duck hunters would often congregate, especially after periodic flash flooding from Bear Creek Canyon. The lake was in the vicinity of Avenue 48 in the north, bounded by Adams Street on the east, Avenue 52 on the south, and the Santa Rosa Mountains on the west. By 1923, the lake had dried up, providing a landing strip for aviators and clay for building the La Quinta Hotel.

Los Angeles 057.

The United States of America,

To all to whom these presents shall come, Greeting:

WHEREAS, a Certificate of the Register of the Land Office at **Los Angeles, California,** has been deposited in the General Land Office, whereby it appears that full payment has been made by the claimant **John L. Marshall** according to the provisions of the Act of Congress of April 24, 1820, entitled "An Act making further provision for the sale of the Public Lands" and the acts supplemental thereto, for the **south half of the northeast quarter and the southeast quarter of Section six in Township six south of Range seven east of the San Bernardino Meridian, California, containing two hundred forty acres,**

according to the Official Plat of the Survey of the said Land, returned to the GENERAL LAND OFFICE by the Surveyor-General:

NOW KNOW YE, That the UNITED STATES OF AMERICA, in consideration of the premises, and in conformity with the several Acts of Congress in such case made and provided, HAS GIVEN AND GRANTED, and by these presents DOES GIVE AND GRANT, unto the said claimant and to the heirs of the said claimant the Tract above described; TO HAVE AND TO HOLD the same, together with all the rights, privileges, immunities, and appurtenances, of whatsoever nature, thereunto belonging, unto the said claimant and to the heirs and assigns of the said claimant forever; subject to any vested and accrued water rights for mining, agricultural, manufacturing, or other purposes, and rights to ditches and reservoirs used in connection with such water rights, as may be recognized and acknowledged by the local customs, laws, and decisions of courts; and there is reserved from the lands hereby granted, a right of way thereon for ditches or canals constructed by the authority of the United States.

IN TESTIMONY WHEREOF, I, **Woodrow Wilson** President of the United States of America, have caused these letters to be made Patent, and the Seal of the General Land Office to be hereunto affixed.

GIVEN under my hand, at the City of Washington, the **TENTH**

(SEAL) day of **APRIL** in the year of our Lord one thousand nine hundred and **FOURTEEN** and of the Independence of the United States the one hundred and **THIRTY-EIGHTH.**

By the President: **Woodrow Wilson,**

By **M.K. Gulick, Assistant** Secretary,

L.Q.C. Lamar, Recorder of the General Land Office.

RECORD OF PATENTS: Patent Number **397495**

Los Angeles 02303.

The United States of America,

To all to whom these presents shall come, Greeting:

WHEREAS, a Certificate of the Register of the Land Office at **Los Angeles, California,** has been deposited in the General Land Office, whereby it appears that full payment has been made by the claimant **Albert P. Green** according to the provisions of the Act of Congress of April 24, 1820, entitled "An Act making further provision for the sale of the Public Lands" and the acts supplemental thereto, for the **south half of the northwest quarter and the north half of the southwest quarter of Section six in Township six south of Range seven east of the San Bernardino Meridian, California, containing one hundred sixty-three and thirty-nine-hundredths acres,**

according to the Official Plat of the Survey of the said Land, returned to the GENERAL LAND OFFICE by the Surveyor-General:

NOW KNOW YE, That the UNITED STATES OF AMERICA, in consideration of the premises, and in conformity with the several Acts of Congress in such case made and provided, HAS GIVEN AND GRANTED, and by these presents DOES GIVE AND GRANT, unto the said claimant and to the heirs of the said claimant the Tract above described; TO HAVE AND TO HOLD the same, together with all the rights, privileges, immunities, and appurtenances, of whatsoever nature, thereunto belonging, unto the said claimant and to the heirs and assigns of the said claimant forever; subject to any vested and accrued water rights for mining, agricultural, manufacturing, or other purposes, and rights to ditches and reservoirs used in connection with such water rights, as may be recognized and acknowledged by the local customs, laws, and decisions of courts; and there is reserved from the lands hereby granted, a right of way thereon for ditches or canals constructed by the authority of the United States.

IN TESTIMONY WHEREOF, I, **Woodrow Wilson** President of the United States of America, have caused these letters to be made Patent, and the Seal of the General Land Office to be hereunto affixed.

GIVEN under my hand, at the City of Washington, the **SIXTH**

(SEAL) day of **MAY** in the year of our Lord one thousand nine hundred and **FOURTEEN** and of the Independence of the United States the one hundred and **THIRTY-EIGHTH.**

By the President: **Woodrow Wilson,**

By **M.O. LeRoy** Secretary,

L.Q.C. Lamar, Recorder of the General Land Office.

RECORD OF PATENTS: Patent Number **402941**

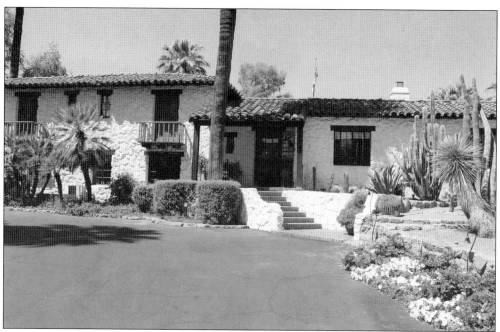

The John L. Marshall main ranch house was built around 1920 using local materials and is a spectacular example of Spanish Colonial Revival architecture. Located on the grounds of Tradition Golf Club at the south end of Washington Street and Avenue 52 in La Quinta, the house has a storied history and was often used for entertaining and as a private respite for many Golden Age of Hollywood celebrities, and Presidents Eisenhower and Kennedy in later years. (Photograph by Sherry Martinez.)

These gates once led to the property and main ranch house and are now at the third hole location on the Tradition golf course. (Photograph by Sherry Martinez.)

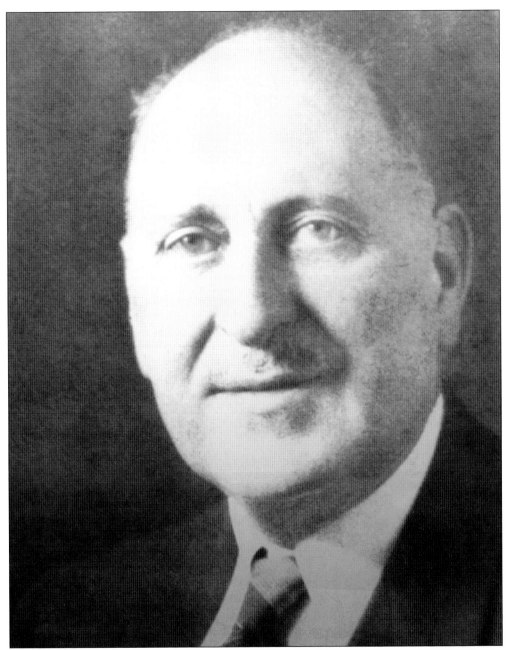

William Starke Rosecrans III was the grandson of Civil War Union major general William Starke Rosecrans. William and Elizabeth Rosecrans bought the Marshall ranch after John Marshall succumbed to a well cave-in accident in 1938. Rosecrans, a wealthy businessman from Los Angeles, renamed the ranch Hacienda del Gato (House of the Cat) after a reported incident where his wife, Elizabeth, was spared from a rattlesnake strike by the family cat. The Rosecranses sold the property in 1954 to citrus ranchers James and Esther Holmes, who removed the date groves due to disease and raised citrus for several years. Later, the property was sold and passed through many developers, including real estate mogul Fritz Burns and the Landmark Land Company. Since 1996, the site has been the home of Tradition Golf Club.

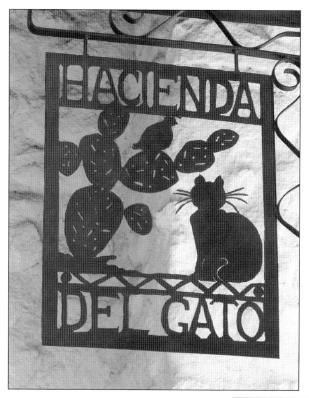

The sign at left pays tribute to the cat that reportedly saved Elizabeth Rosecrans; below is the site of the cat's grave, which is marked by an iron cross and interwoven rosary beads. The cat lived for another 20 years after the incident. Although its name has been lost to history, visitors still frequently inquire about the story and burial site when stopping by the hacienda. (Both photographs by Sherry Martinez.)

These are additional views of the original entrance gates to Hacienda del Gato, with large non-native palms in the distance. The large trees in the foreground may have been original to the grounds. One wall enclosing the historical gates leading to the main ranch house is adorned with the original Hacienda del Gato tilework, which is gracefully aging in place. (Both photographs by Sherry Martinez.)

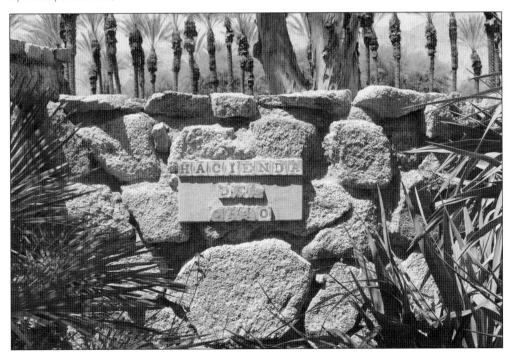

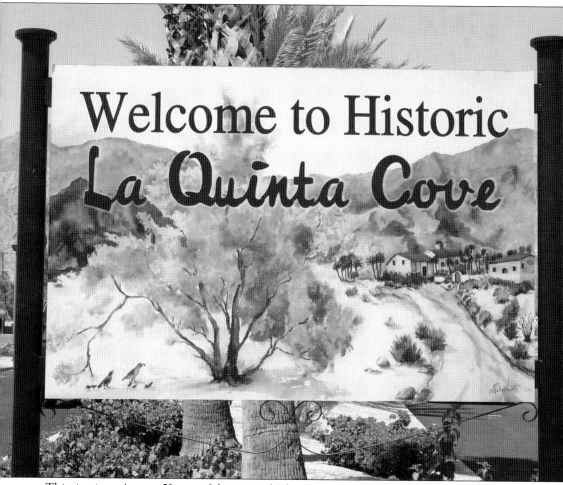

This sign is on Avenue 52 west of the original John Marshall Ranch near Fire Station 32. Another one is on Eisenhower Drive and Avenida Montezuma in La Quinta. The area known as Marshall's Cove was the first subdivision (1933–1937) in what would become the City of La Quinta many years later. The first company to supply power to the Cove, Coachella Valley Ice and Electric, controlled by W.F. Holt, arrived by November 1919. While there are many gated communities throughout La Quinta today, the original Cove area was built without gates or even paved roads in mind. Elevation differences in the area often resulted in flash flooding from the nearby Santa Rosa Mountains. The number of homes in the historic neighborhood steadily increased over the years and now exceeds 5,000, including an eclectic mix of artists, artisans, retirees, and young families with architectural styles ranging from historic Spanish Colonial Revival–themed casitas built between 1935 and 1941 to modern and contemporary post–World War II housing. (Courtesy of Sherry Martinez.)

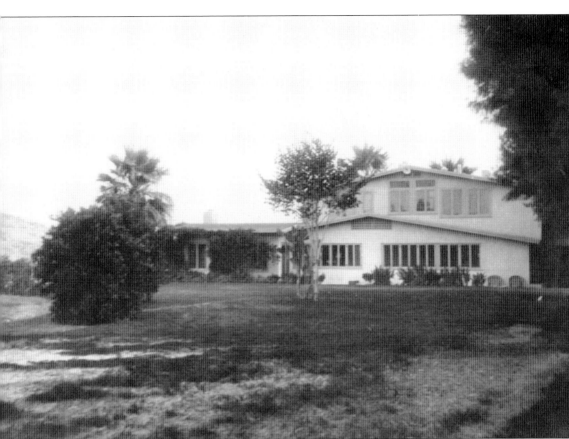

This is the main house of Chauncey D. and Marie Rankin Clarke at the Point Happy Date Gardens property. It was considered a showcase from 1923 to 1952 with its many gardens and included two swimming pools, an archery range, and bridle paths. As a working ranch, the abundance of fruits and vegetables provided all who lived and worked at the ranch a cornucopia of riches. The ranch offered Deglet Noor dates and a variety of citrus, including limes and tangerines. The ranch house was ahead of its time, with solar heating and a solid copper roof. Later, air conditioning was added, even in the homes of the workers, and each family had a radio. The Clarkes entertained frequently, and many prominent politicians, along with a number of Hollywood celebrities, such as Rudolph Valentino, John Barrymore, and Clark Gable, were often seen on the property. Valentino had an especial affinity for Jadaan, the gray Arabian stallion owned by the Clarkes that he rode in his films, and visited often.

Chauncey D. Clarke was a devoted Arabian horse enthusiast. He brought six Arabian mares and five Arabian stallions, including Jadaan, to Point Happy Date Gardens in 1925. Falling seriously ill a short time later, he sold his Arabians to the W.K. Kellogg Ranch in Pomona, where they became prized breeding stock. Clarke died on August 22, 1926.

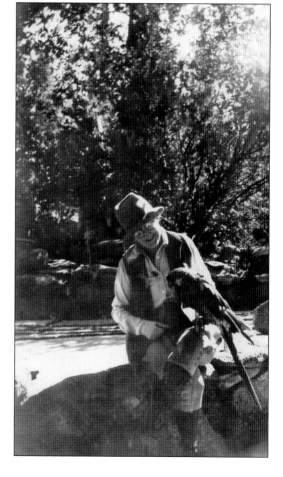

Marie Rankin Clarke is shown holding a parrot in the Point Happy Date Gardens. Active at the property after Chauncey's death, she was fondly remembered as someone who frequently used the phrase "common denominator" in conversation. Upon her death in 1948, Claremont College inherited the estate property, valued at $5 million at the time. The college sold the gardens to William Dupont Jr. in the 1950s, and the property was further subdivided upon Dupont's death in 1965.

Jadaan was legendary in his own right, appearing in six films. He became enormously popular after Valentino's death in 1926 and was in constant demand for appearances. He was in three Pasadena Tournament of Roses parades and lived to be 29 years of age. Valentino is pictured at right riding Jadaan while visiting the John Marshall Ranch around 1925, before his untimely death in 1926. The postcard below features Valentino on Jadaan in *Son of the Sheik*. (Right, courtesy of Tradition Golf Club.)

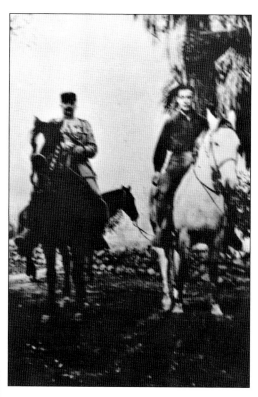

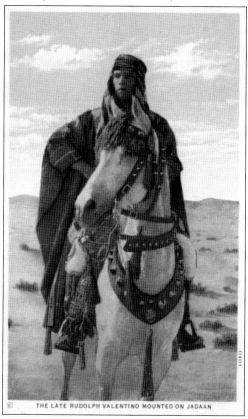

THE LATE RUDOLPH VALENTINO MOUNTED ON JADAAN

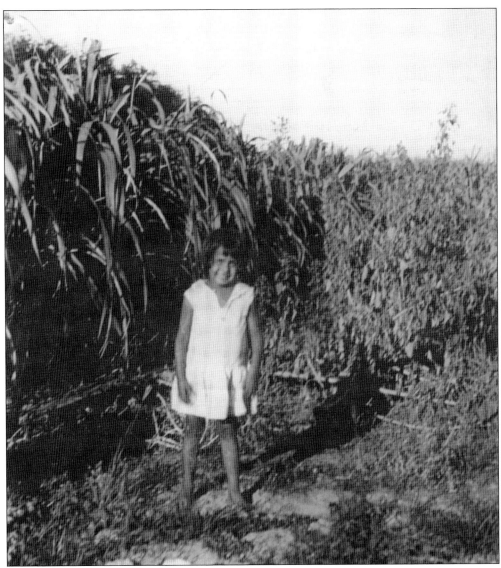

A young Josephine Rodarte is pictured in a sugarcane field at Point Happy Date Gardens in 1931. In 1923, Josephine's father, Teofilo Rodarte, was hired by the Clarkes as foreman for Point Happy Date Gardens, followed by her uncle Jess Rodarte, to tend the date groves. Her father remained in the position until his death in 1943. Her mother, Juanita Rodarte, was the housekeeper for the Clarkes. The Clarkes' full-time gardener, Mr. Akahoski, planted large vegetable gardens for the home's needs and maintained extensive rose and flower gardens, often showcased by the Clarkes when entertaining friends and celebrities. Josephine and her siblings were all born at the ranch, attended Point Happy Elementary School, and often played among the gardens, bridle paths, and citrus groves, along with cooling off on hot summer days in the large swimming pool.

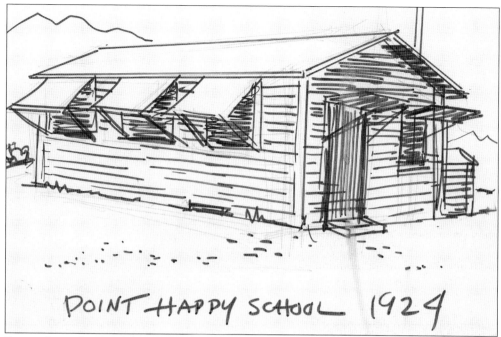

POINT HAPPY SCHOOL 1924

Pictured is a sketch of the second Point Happy Elementary School around 1924 and a class photograph from 1923, with teacher Mrs. Fremar. The school was moved close to the former Carl Bray art studio on Highway 111 in present-day Indian Wells, California, around 1918. With no well drilled on the property until 1920, students carried drinking water from Carl Bray's store, about 100 yards away. After 1923, the majority of students were from the Mexican, Japanese, and Caucasian families working at nearby Point Happy Date Gardens owned by the Clarkes. In 1925, the school had 21 students. Edith Wild White, an early settler in the Coachella Valley, was the schoolteacher at one time. She also served on a number of committees and often helped her husband, John, drill wells for new homesteaders in the area.

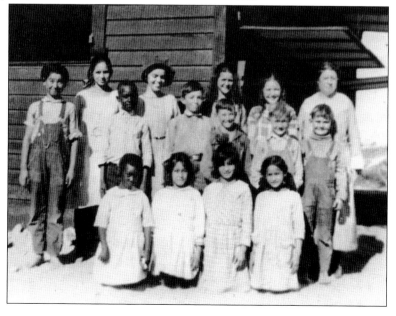

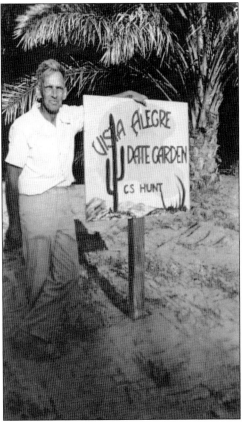

The C.S. Hunts are seen above in 1934, looking out onto what would become the busy intersection of Washington Street and Highway 111 in La Quinta. A friend, Fred Ickes, migrated to the area in the 1920s with brother-in-law Mead Vaiden with funds loaned from Clinton Hunt. They started a date grove and citrus orchard just northeast of the La Quinta Hotel. The Hunts followed in 1932, and Ickes repaid the loan by giving them the date grove, which they named Vista Alegre (Happy View in Spanish). Vaiden retained the property on the opposite corner. The Hunts grew dates and row crops, raised chickens, and had a packinghouse. The Montoya family lived in an adobe structure on the property. In 1948, the Hunts returned to New York, and C.S. Hunt returned to his former profession as an engineer. A Mr. Jarvis bought the ranch and planted a citrus grove.

Pictured above are the Hunts at their Vista Alegre ranch grape arbor, and below is a photograph of Mary Hunt awaiting customers at her roadside date stand in the open desert, with only an umbrella for shade, possibly along Marshall Road. Notice the scale for weighing dates, which were usually sold by the pound. Some jars and citrus are also seen on the table, presumably for sale. The flowers at lower left and the Adirondack-style chairs could also have been for sale or simply decoration for the stand.

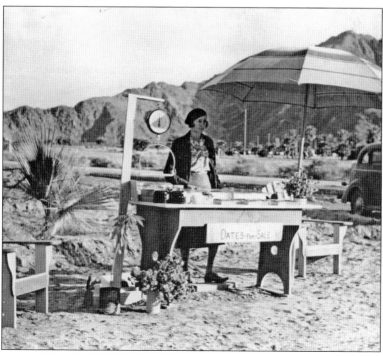

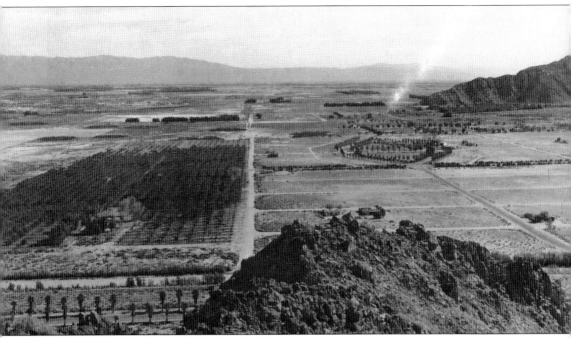

Pictured is an aerial view of the Hunt/Vaiden ranch properties. At the time of the photograph, the La Quinta area was still relatively undeveloped, with ranchers and settlers beginning to grow row crops and plant citrus and date groves. The infilling of the area would take quite a few more years with properties changing hands frequently due to financial hardship, land speculation, or the harshness of the environment alternating between drought and flash flooding, which often destroyed crops and livelihoods. Roads were mostly dirt or oiled in some cases, and few amenities existed. Telephone service and electricity were in the beginning stages, and most ranchers and settlers continued to dig artesian wells and use pumps to divert the water to crops and residences. Some community water systems were beginning to form, but they would take years to replace the wells.

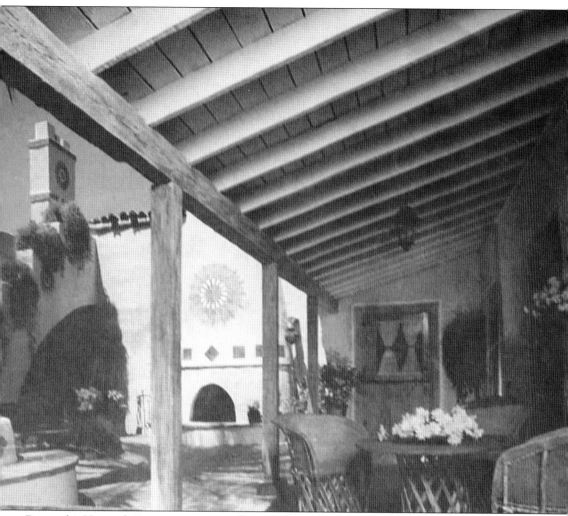

Pictured is Hacienda Serena, an estate reflecting old California charm bordering the La Quinta Hotel property. Originally built in 1922, the 3,450-square-foot adobe has a long and fascinating lineage of owners, including, though never confirmed, that the estate was built for Prince Edward in 1922. Walter H. Morgan stayed there from time to time before building the La Quinta Hotel and the Morgan House. The estate has hosted royalty and a number of celebrities over the years. Owners include industrialist George Reitel and renowned polo player Fremont Hitchcock Jr. At almost two acres, the estate has expansive lawns, orchards, and gardens complemented by a large swimming pool and a stately fountain—serenity indeed.

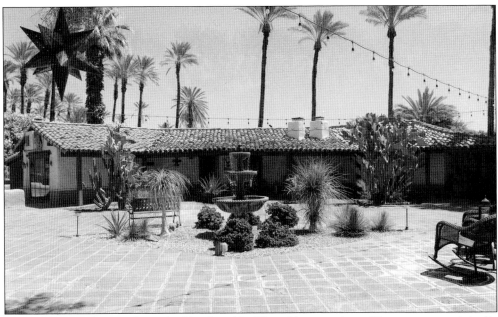

The adobe main house of Rancho Tecolote (Owl Ranch) is seen here. The structure, originally built around 1926 in Thermal, now stands within the city of La Quinta. Dates and cotton were grown from around 1918. The site has had many owners, including noted artist and painter Frances Roberts Nugent (1904–1963). The ranch provided a haven for the rich and famous. One owner, Brian Aherne, and his wife, Joan Fontaine, built a guest casita on the property for visiting friend Prince Rainier of Monaco. The Marx brothers reportedly frequented the ranch on several occasions. The large cacti are over 100 years old, and the adjoining date grove still produces dates. The property has been restored to much of its former grandeur by current owners John Miller and James Blanton, who renamed the site the J & J Ranch in 2012. (Both photographs by Sherry Martinez.)

Five

THE LA QUINTA HOTEL

In 1921, Walter H. Morgan, son of John S. Morgan of San Francisco, the wealthy owner of Morgan Oyster Company, was granted a federal land patent of 1,400 acres south of Point Happy Date Gardens.

Morgan formed the Desert Development Company with friend Fred Ickes with plans to build a luxury hotel where guests could be provided an exclusive, secluded retreat. He hired noted architect Gordon B. Kaufman of Pasadena, California, in 1925 to design it, with Kaufman later receiving a Certificate of Honor from the American Institute of Architects for outstanding work on the Spanish Colonial Revival–themed hotel. The grounds were designed by Edward Huntsman-Trout.

Construction costs for the main building and lobby areas, dining room, office, and the first six cottages, or casitas, were estimated at $150,000–200,000. Labor was supplied by local companies, area tradesmen, and residents. Homestead rancher Manning Burkett, also a finish carpenter, was involved with building the hotel, as was Raymond Pedersen, a nearby rancher and contractor, who worked on the hotel and casitas.

Rather than have brick and tile shipped in, two kilns were built at the site. Over 165,000 adobe bricks and tiles were handmade by neighboring Joe Valenzuela Roof Company, with clay taken from the Marshall/Green lakebed.

As to the name Morgan chose for the hotel, one popular story maintains it originated with Raymond Pedersen telling him of a country estate or hacienda in Mexico surrounded by casitas, named La Quinta.

The hotel opened during the December holiday season in 1926, followed with a successful grand opening to the public on January 29, 1927, attended by 125 people.

The hotel had the first golf course in the Coachella Valley, with nine holes designed by noted course architect Norman MacBeth. The course was open to the public, with greens fees of $1. The hotel also had a landing strip, stables, and reportedly, the first telephone service in the area.

Morgan, suffering from tuberculosis coupled with financial problems stemming from the Great Depression, committed suicide in 1931. His ashes were spread over the hotel grounds, and the hotel went into receivership, passing through several owners, including Chicago attorney Leonard Ettleson and charter members of the La Quinta Country Club, who revitalized the resort.

In 1977, Landmark Land Company bought the property, designed major upgrades to the golf course, and added 193 rooms and suites to the remarkable hotel.

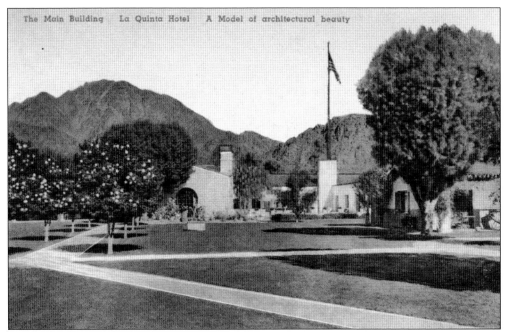

This c. 1950 Photochrome postcard of the La Quinta Hotel displays the layout of the hotel, including the 125-foot flagpole. The flag regularly flew over the grounds and mature grapefruit and orange trees. The Santa Rosa Mountains are to the west of the hotel.

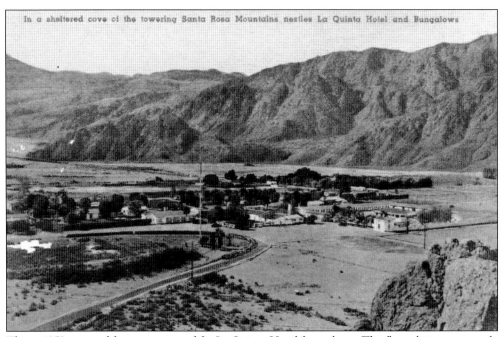

This c. 1950 postcard features a view of the La Quinta Hotel from above. The flagpole is prominently featured, as are the spectacular Santa Rosa Mountains. The riding stables and casitas are visible around the main building. The surrounding area appears open and undeveloped; this would change significantly in the years to come.

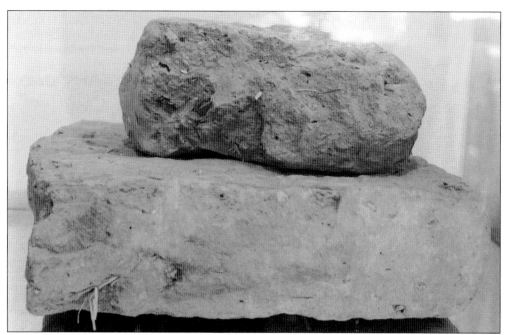

These are some of the original adobe bricks used in the construction of the La Quinta Hotel and the first 20 casitas. Joe Valenzuela, owner of a local roof company, supervised the making of over 100,000 bricks, 60,000 roof tiles, and 5,000 floor tiles. The roof tiles were hand-formed by taking wet clay, mixing it with straw and bits of iron, and forming them over the workman's thigh, then leaving them to dry in the sun for a few days. (Courtesy of Sherry Martinez.)

Pictured is the new drive entrance to the La Quinta Hotel around 1970 with lush palms, gardens, and the Santa Rosa Mountains as a backdrop. The original gardens were designed by Edward Huntsman-Trout, and per Morgan's directive, incorporated as much of the surrounding natural landscape views as possible.

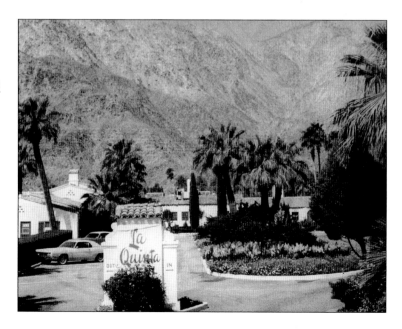

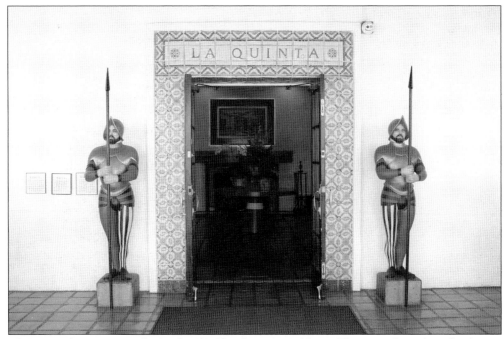

The original entrance to the La Quinta Hotel is pictured here. The central porch and columns are stucco cladding, as are the main L-shaped building and north-south and east-west wings. Double doors greet guests, and "La Quinta" is spelled in blue letters over the entrance. Ornate tiling was incorporated into many parts of the hotel, including walkways and fireplaces. The Spanish conquistadors guarding the entrance were added later and were not part of the original design. (Courtesy of Sherry Martinez.)

This is an original hand-painted Mexican tile at the La Quinta Hotel, using blue, red, and yellow and measuring approximately four to six inches square. Tiles such as this were inset in various parts of the hotel, adding to its charm and the feel of an old colonial Spanish or Mexican estate. (Courtesy of Sherry Martinez.)

Pictured is a lamp fixture resembling a mission bell from the La Quinta Hotel with a date of 1926. These lamps were often seen around the property.

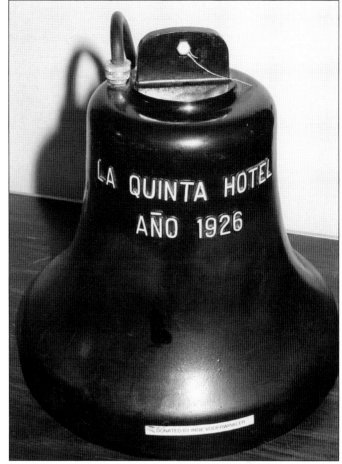

The original fountain designed for the La Quinta Hotel is seen here in 1934. The landscaping had matured by then, providing a stunning view against the backdrop of the Santa Rosa Mountains. The area around the fountain was designed and built with flat Saltillo square tiles.

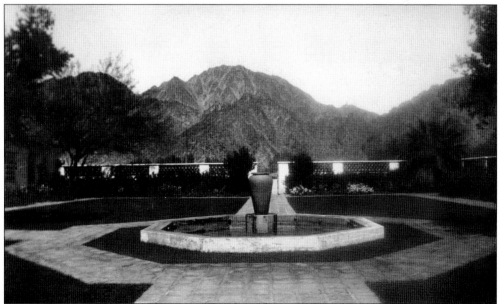

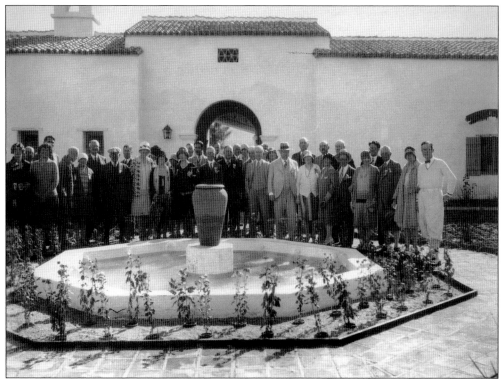

Pictured are 125 friends and dignitaries attending the public grand opening of the La Quinta Hotel on January 29, 1927. An earlier "soft" opening was held by Walter Morgan in December 1926. The plants around the fountain are newly planted, and bare earth still surrounds the grounds beyond the fountain. The rooms were all booked at the time of the grand opening, and Morgan's efforts were off to a good start for guests desiring a secluded luxury hotel. Due to the savvy marketing efforts of Walter Morgan and his connections to influential people in trade, commerce, and Hollywood, word of the hotel spread. By 1949, massage services had been added to the hotel's amenities, and the tourist trade grew even more.

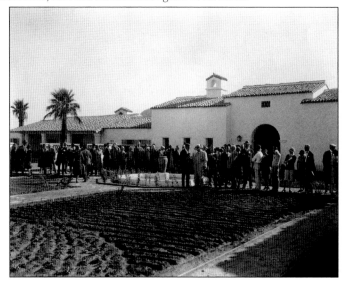

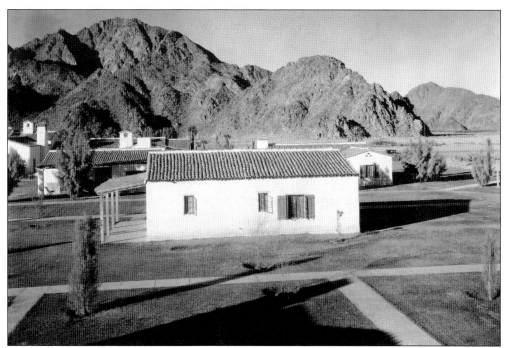

One of the original casitas at the La Quinta Hotel is shown here. The casitas were spread out from each other and basically looked the same. They were built of the same materials as the main hotel. The casitas were often in demand by guests desiring a quiet, secluded interlude or vacation. Many Hollywood stars stayed in them and took advantage of the hotel's simple, but restorative, amenities.

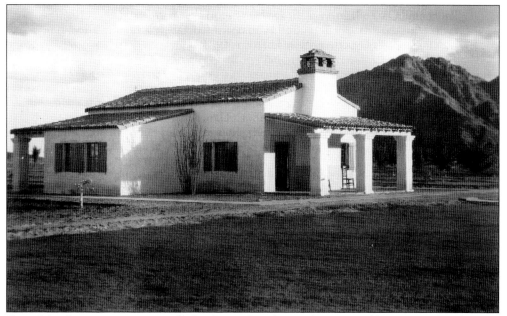

One of the three-room casitas on the La Quinta Hotel grounds is pictured here. Note the "chimney pot" feature. Shutters, window sashes, and doors at the casitas were painted in a special shade of blue thought to ward off evil spirits.

Pictured is an original writing desk from the La Quinta Hotel. It would have provided a convenient space to write letters and postcards as well as tending to business, such as paying bills or logging in guest requests. One can only wonder at the variety of notes and articles that must have been written here during its days at the hotel.

This was a typical casita room in the early days. Rooms were small, with adobe wall stucco cladding. Furnishings were sparse by today's standards. In the 1929–1930 season, the rate for a room was $15 a night for one person and $25 for two, with lunch or dinner costing $2.50. The season ran from November 1 to May 1.

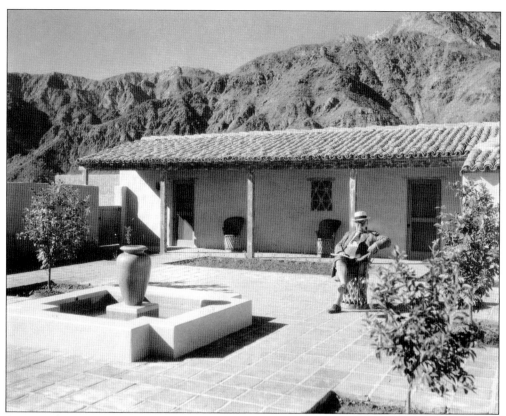

A man relaxes in the private patio of a residence at the La Quinta Hotel around 1927. The flat Saltillo tiles are striking along with the smaller version of the fountain at the front of the hotel. The photograph shows the red tile roof and relatively new landscaping.

This photograph appears to show a game of badminton in progress, with the shuttlecock high in the air but no net. By this time, grass was growing on the grounds. The man at right is wearing saddle shoes, which were popular throughout the 1930s and 1940s.

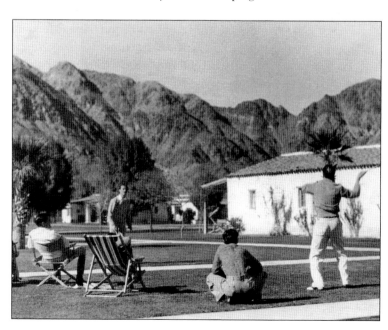

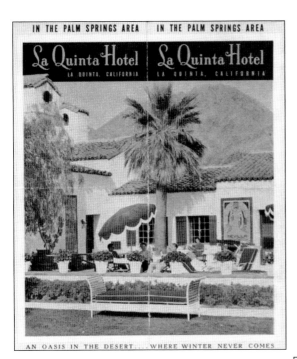

IN THE PALM SPRINGS AREA IN THE PALM SPRINGS AREA

La Quinta Hotel La Quinta Hotel
LA QUINTA, CALIFORNIA LA QUINTA, CALIFORNIA

AN OASIS IN THE DESERT... WHERE WINTER NEVER COMES

Promotional brochures like this were commonly used to entice people to the Coachella Valley, especially Palm Springs and points farther east. "Where Winter Never Comes" was a common marketing slogan of the La Quinta Hotel, attracting many guests every season.

Buenos Dias! Amigos! I bring you news of La Quinta Hotel in the enclosed illustrated folder. New attractions- new swimming pool- new management. You'll like La Quinta now- more than ever- Opening Nov. 20th Hasta la Vista!

Little Joe was the official mascot of the La Quinta Hotel until the 1970s, when he was quietly retired. Little Joe appeared on practically everything related to the hotel, from dinnerware and golf bags to letterhead, matches, and ashtrays.

from _____

MERCHANDISE—FOURTH CLASS MAIL. This package may be opened for Postal Inspection. Return or forwarding postage guaranteed by the shipper.

La Quinta Hotel

LA QUINTA, CALIFORNIA
(IN THE PALM SPRINGS AREA)

for _____

This mailing label from the La Quinta Hotel featured Little Joe. Because the hotel was about 20 miles beyond Palm Springs and Palm Springs was more widely known, a reference to being "in the Palm Springs area" was frequently added to hotel materials to help with attracting guests.

La Quinta Hotel

NEW YEAR'S EVE DINNER
1937-1938

APPETIZERS
> Colorado Celery Colossal Mixed Olives
> Salted Jordan Almonds
> Lobster Cocktail Favorite
> * * *

SOUPS
> Cream of Chicken Royale
> Clear Green Turtle
> * * *

FISH
> Saute California Brook Trout
> Browned Lemon Butter
> Sliced Cucumbers
> * * *

ENTREES
> Boneless Ideal Squab en Farci Under Glass
> Broiled Tenderloin Steak au Champignons
> * * *

VEGETABLES
> Julienne Green Beans Carrots Louise
> Butterball New Potatoes
> * * *

SALAD
> Endive and Avocado Lemon Oil Dressing
> * * *

DESSERTS
> "La Quinta" Date Pudding, Orange Sauce
> Frozen Cream Puff, Chocolate Sauce
> Petit Fours, 1938
> Fruits and Nuts
> Mints
> * * *

COFFEE
> Demi Tasse

Pictured is the 1937–1938 New Year's Eve menu. The hotel was enormously popular with Hollywood and international stars attending New Year's Eve parties. A specialty listed for dessert was "La Quinta" date pudding, possibly made from dates harvested from the date groves on the property.

Farrah Fawcett	Don Johnson	Donna Mills
Joely Fisher	Casey Kasem	Robert Montgomery
Errol Flynn	Diane Keaton	Rupert Murdoch
Jane Fonda	Howard Keil	Bill Murray
Betty Ford	Harvey Keitel	Don Murray
Harrison Ford	Ben Kingsley	Bob Newhart
Michael Franks	Calvin Klein	Leonard Nimoy
Mary Frann	Bernie Kopell	Hugh O'Brien
Clark Gable	Cheryl Ladd	Pat O'Brien
Greta Garbo	Jessica Lange	Nancy O'Dell
Pancho Gonzalez	Cloris Leachman	Al Pacino
Linda Grey	Jerry Lewis	George Patton
Jasmine Guy	Sheri Lewis	George Peppard
Gene Hackman	Rush Limbaugh	Rhea Perlman
George Hamilton	Hal Linden	Matthew Perry
Tom Hanks	Shelley Long	Joe Pesci
Valerie Harper	George Lucas	Christopher Plummer
Chris Harrison	Michael Madsen	Morey Povich
Mary Hart	Howie Mandell	Stephanie Powers
David Hasselhoff	Pamela Sue Martin	Don Rickles
Katherine Hepburn	Jackie Mason	Pat Riley
Charlston Heston	Gary McCord	Cliff Robertson
Gregory Hines	Joel McCrea	Ginger Rogers
Katie Holmes	Dylan McDermott	Mickey Rooney
Lou Holtz	Roddy McDowell	Katherine Ross
Bob Hope	Ali McGraw	Dick Rutan
Angelica Houston	Ed McMahon	Adam Sandler
Samuel L. Jackson	Sergio Mendez	

A partial guest list of celebrities that frequented the La Quinta Hotel is seen here. Many of the Golden Age of Hollywood actors and actresses visited often in the early days, including Greta Garbo, Errol Flynn, Clark Gable, Bette Davis, and Joan Crawford. The list would grow to include a large number of prominent businessmen, politicians, and sports figures in the ensuing decades.

A young Robert Wagner tries his hand at horseback riding around late 1937. He has frequented the La Quinta Hotel from an early age.

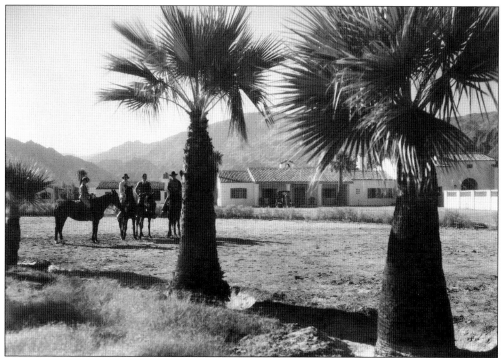

Pictured are horseback riders enjoying a stop on the grounds of the La Quinta Hotel. Most likely, the horses were saddled from the stables at the hotel. Riding horses was a preferred activity for some guests. Stately and distinctive California desert fan palms (*Washingtonia filifera*) with their thick trunks are shown.

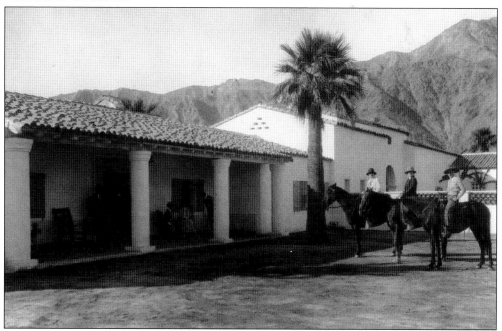

Horseback riding enthusiasts stop at the front entrance of the La Quinta Hotel. Some are in sweaters, which would imply it is the spring or fall. The tiled wall behind the riders was removed later.

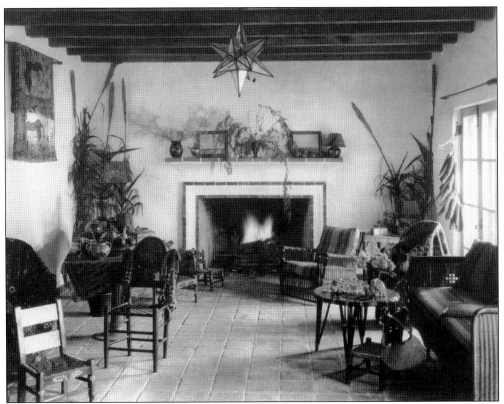

An enchanting atmosphere awaited any guest entering this hotel room. Heavy wooden beams, warm Saltillo floor tiles, Mission-themed furniture, Southwest-themed fabrics, a cozy fire in the tiled fireplace, and a fireplace mantel graced with smoke tree and honey mesquite branches projected a welcoming atmosphere, something Walter Morgan strived for.

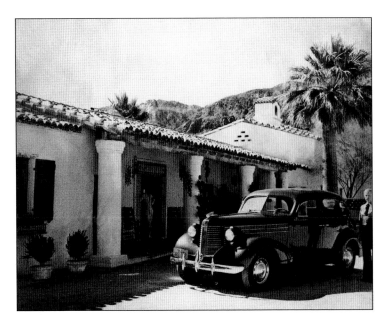

The image of luxury and refinement, this car posed outside the entrance of the La Quinta Hotel was part of a marketing campaign directed at the wealthy and famous.

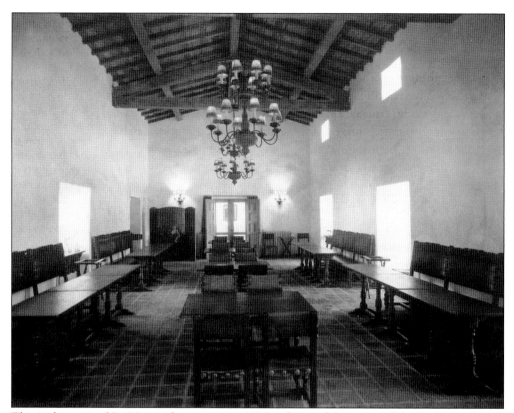

This is the original La Mirage dining area in 1926 as designed for guests of the La Quinta Hotel. The chandelier, sconces, and Saltillo floor tiles accentuate the richness of the room, another hallmark of Morgan's and Kaufman's marketing ingenuity. The furniture and lights at the hotel were also designed by Kaufman, who was known for his high standards.

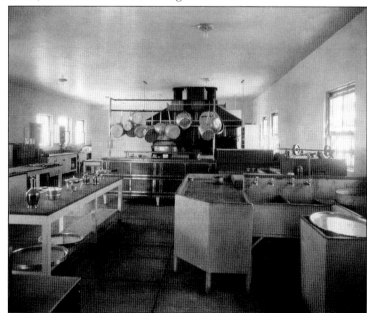

A later version of the kitchen area is pictured here. Food preparation, quality of food, and fine dining were paramount in Morgan's efforts to attract guests to the hotel.

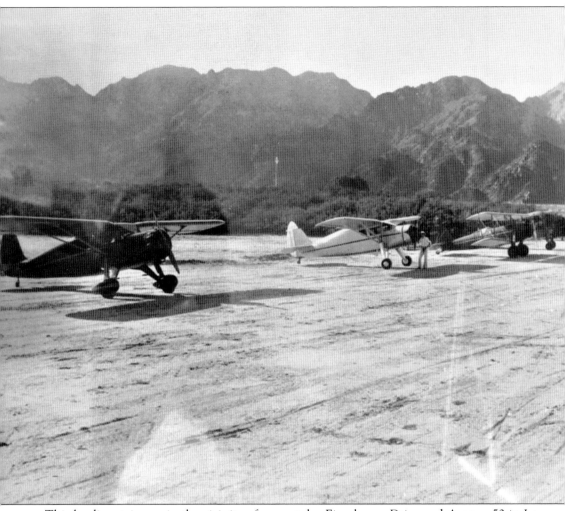

This landing strip was in the vicinity of present-day Eisenhower Drive and Avenue 50 in La Quinta. As aviation improved, more and more guests flew to the La Quinta Hotel for a day of golf, picnicking, or an extended stay. An interesting story relayed on the Aviation Country Club of California history site tells of members flying to a landing strip near the La Quinta Hotel on December 7, 1941, and participating in a tour of the hotel when word of the attack at Pearl Harbor came over the radio. Members ran to the landing strip and their planes to return home. Several were greeted by soldiers at their various airfields who promptly removed the propellers from their planes and stored them, as anti-aircraft guns were firing indiscriminately at anything in the sky, including small aircraft such as theirs. Small, private planes were prohibited from flying for the duration of World War II. On December 7, 1991, a flight and tour by club members to the La Quinta Hotel commemorated the 50th anniversary of the event with four original flight members in attendance.

Pictured are legendary film director Frank Capra and his wife, Lucille. Frank Capra visited the La Quinta Hotel in the 1930s and considered it his lucky place to create and write movie scripts. In 1934, he received an Academy Award in all five major categories for the film *It Happened One Night*, which he composed while at the hotel. He would return many times over the years to work on other scripts and was active in the La Quinta community. The couple also built a home at La Quinta Country Club near the 10th tee in the 1960s, where they lived until moving to the San Anselmo casita at the La Quinta Hotel in 1980. Frank Capra was often seen visiting with guests staying at the hotel. The Capras were very much a part of La Quinta history.

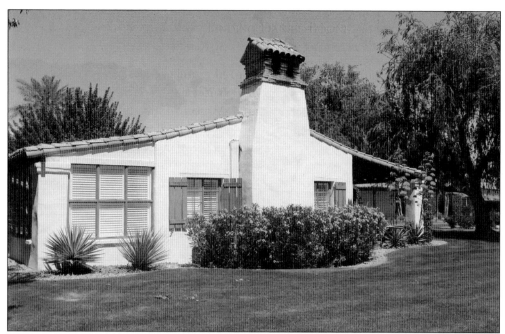

The Capras' San Anselmo casita is pictured here. The La Quinta Hotel grounds were originally centered around three courtyards, one of which consists of an interior oval that the casita is located on. Walter Morgan named the 20 original casitas for saints, and the casita the Capras resided in was named San Anselmo. Keeping with the original design concepts, walls are adobe-covered cladding, with the shutters, window sashes, and doors painted blue and the tiled roof and the charming chimney pot and overhangs red. Landscaping around the casita consists of native desert plants such as agaves and cacti. (Both, courtesy of Sherry Martinez.)

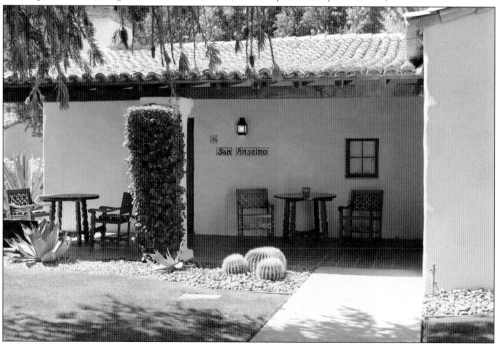

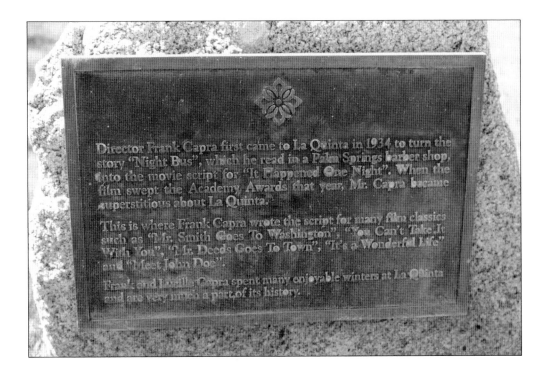

This marker and bench are dedicated to the Capras. In addition to *It Happened One Night*, Capra wrote the script for many classic films such as *Mr. Smith Goes to Washington*, *You Can't Take It With You*, *Mr. Deeds Goes to Town*, *It's a Wonderful Life*, and *Meet John Doe* here. Lucille died in 1984, and Frank in 1991. Both are buried in the Coachella Valley Public Cemetery. (Both, courtesy of Sherry Martinez.)

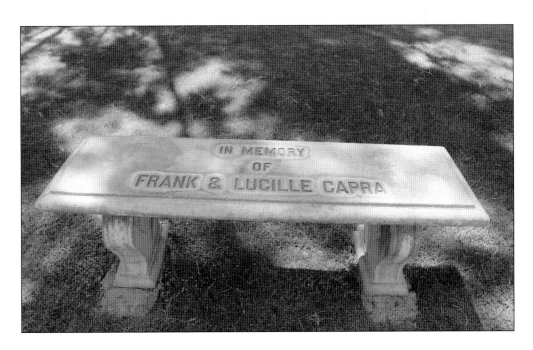

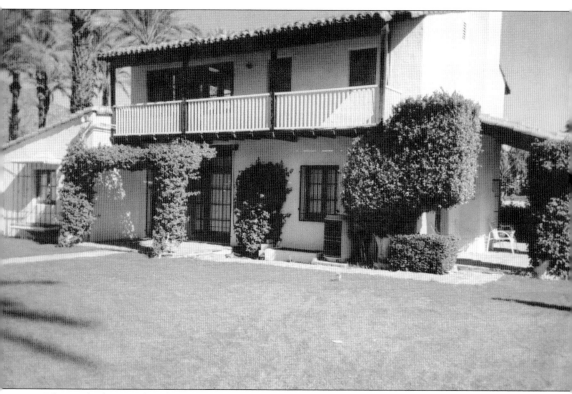

This is the home of Walter H. Morgan, owner and manager of the La Quinta Hotel. The house is on the northwest corner of the hotel property. The architect was Gordon B. Kaufman, and the house was built in 1926–1927 using local tradesmen and contractors. It is a classic example of the Spanish Colonial Revival style with Monterey influences incorporating desert elements into the design of the house and grounds. The two-story structure is virtually unchanged since its construction with adobe walls covered with stucco cladding, along with handmade roof tiles made by the Joe Valenzuela Roof Company, which also made the adobe bricks and tiles for the hotel.

Six

SANTA CARMELITA DEL VALE AND THE DESERT CLUB

During the Depression in 1932, electricity supplied by the Southern Sierra Power Company arrived in the area, as did Guild Moccasin Company executive E.S. "Harry" Kiener. He purchased several thousand acres around the La Quinta Hotel, naming the property Rancho La Quinta. Actor Marlon Brando and Anna Kashfi were married at the ranch in 1957, with Rock Hudson in attendance. The property would become the Olive Ranch in the 1960s and the Enclave Estates in the 1990s.

Kiener planted dates and citrus but also formed the Palm Springs–La Quinta Development Company, with plans to subdivide some of his property. This led to Santa Carmelita del Vale subdivision being approved by Riverside County and building Spanish Colonial Revival–themed casitas, fashioned on the nearby La Quinta Hotel casitas, on 50-by-100-foot lots that could be sold or leased. Lots sold for $195, casitas for $2,500, with the buyer able to select the location. A handful of casitas were built in 1935, with a total of 63 constructed by the early 1940s.

Another aspect of Kiener's plan was to build a club in the Cove with dining and swimming amenities to attract visitors. He fell ill in 1936 and sold his interests to his salesmen Edward Glick and Frank Stone, who continued selling lots and homes using brochures referring to the Cove as Vale La Quinta. They followed through on building the Desert Club on the corner of Avenidas Bermudas and Avenue 52 in La Quinta, opening on Thanksgiving Day 1937.

The building, designed by noted architect S. Charles Lee in the fashionable Art Moderne style of the 1930s, resembled a riverboat with rounded curves, smokestack, and portholes. Waiters served guests in coat and tie in the luxurious dining room. It became a favorite among Hollywood stars, businessmen, and visiting dignitaries, much like the La Quinta Hotel. Early patrons included Virginia Mayo, Kirk Douglas, James Drury, Rita Hayworth, and William Dupont Jr., among others.

Fire damaged the club in 1965, and although rebuilt, it frequently changed hands, steadily declining and finally closing in the mid-1980s. Owner Fritz Burns deeded the property to the City of La Quinta. It was razed by the county fire department in 1989, and Fritz Burns Park now stands in its place.

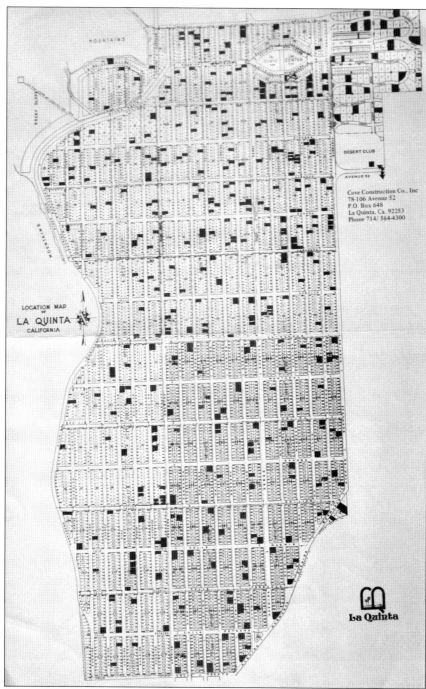

A map of the new subdivision, Santa Carmelita del Vale, is pictured. Streets were unpaved and laid out following a grid pattern of *calles* (streets) running north-south and *avenidas* (avenues) east-west. Boundaries of the subdivision were defined as Tampico to the north, Tecate to the south, Bermudas to the east, and Montezuma to the west and were the beginning of defining the historic Cove community of La Quinta. Early maps drawn after 1936 were often stamped with "La Quinta, California."

The structure pictured on this brochure was on the southeast corner of Washington Street and Highway 111 in La Quinta. It was used in marketing for attracting new residents to the La Quinta area and was featured prominently on brochures in the late 1930s.

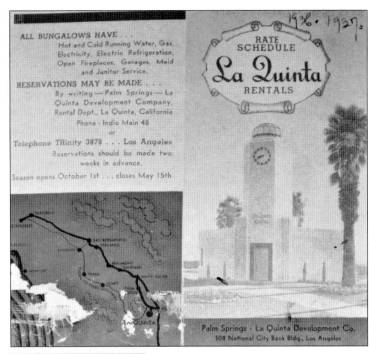

ALL BUNGALOWS HAVE . . .
Hot and Cold Running Water, Gas, Electricity, Electric Refrigeration, Open Fireplaces, Garages, Maid and Janitor Service.

RESERVATIONS MAY BE MADE . . .
By writing — Palm Springs — La Quinta Development Company, Rental Dept., La Quinta, California
Phone - Indio Main 48
or
Telephone TRinity 3878 . . . Los Angeles
Reservations should be made two weeks in advance.

Season opens October 1st . . . closes May 15th

RATE SCHEDULE
La Quinta
RENTALS

Palm Springs - La Quinta Development Co.
508 National City Bank Bldg., Los Angeles

The new subdivision Santa Carmelita del Vale had street markers denoting calles and avenidas, such as the one shown here. On the originals, the street names were attached to the top of the concrete markers. Over time, they broke off or were lost. New markers around 1965 began to replace them with the names painted on the sides. The calles were named for states in Mexico, while avenidas were named for notable Mexican personalities. Many markers can still be seen throughout the historic Cove area today.

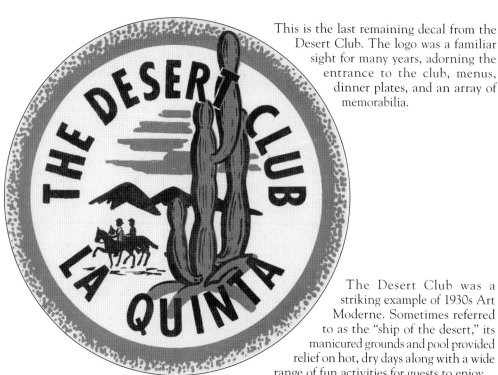

This is the last remaining decal from the Desert Club. The logo was a familiar sight for many years, adorning the entrance to the club, menus, dinner plates, and an array of memorabilia.

The Desert Club was a striking example of 1930s Art Moderne. Sometimes referred to as the "ship of the desert," its manicured grounds and pool provided relief on hot, dry days along with a wide range of fun activities for guests to enjoy.

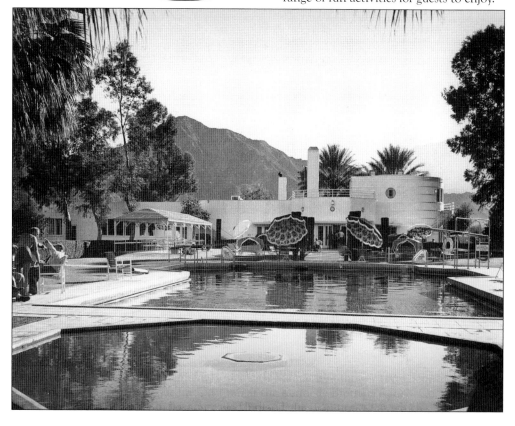

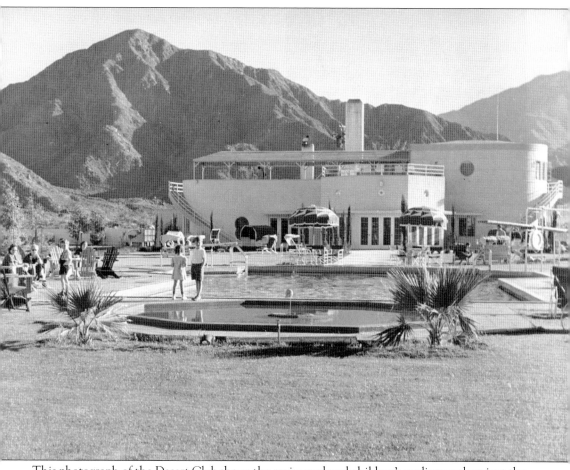

This photograph of the Desert Club shows the main pool and children's wading pool against the backdrop of the Santa Rosa Mountains. The main pool was eight-sided and provided hours of fun in the sun for guests. The pool was tiled and had a diving board, with Saltillo tiles leading to the pool area.

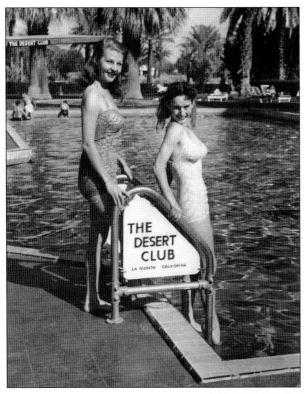

The Desert Club was considered a hideout for Hollywood stars and other celebrities seeking a break from their busy schedules and public lives. In the 1940s, Gen. George S. Patton often visited the Desert Club as the 3rd Army trained in the desert at Camp Young. At left, Rita Hayworth and a friend display the one-piece bathing suits of the 1950s, while the ever-popular two-piece bikini makes an appearance (below) a few years later.

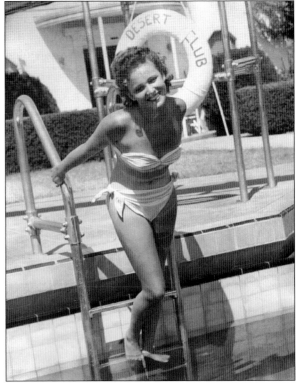

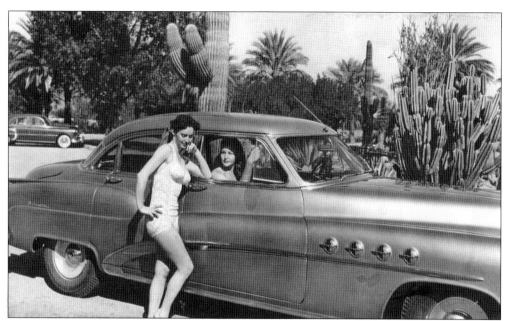

Rita Hayworth and a friend spend time chatting and catching the sun at the Desert Club with their Buick carrying 1952 license plates. Large cars like this were popular at the time, providing a gentler ride around the area, as many roads were still unpaved and bumpy. Saguaro cacti, like the ones in the background, were not native to the area. They were landscaped into the sandy Desert Club grounds and displayed prominently as well on the Desert Club logo and decals, providing a contrast to the nautical theme of the Desert Club building design.

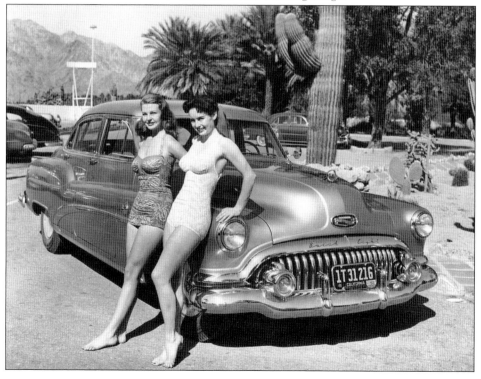

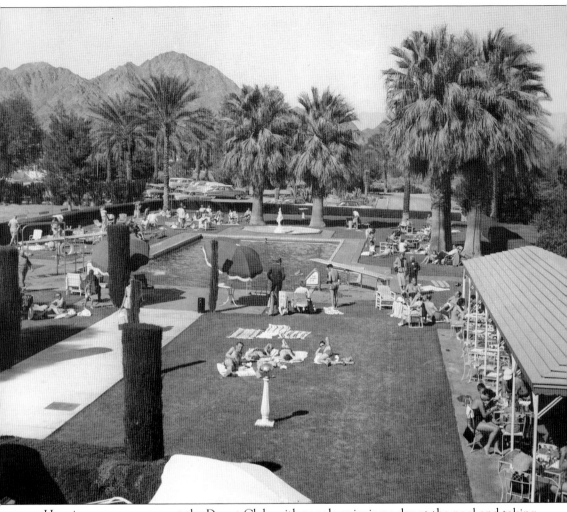

Here is a common scene at the Desert Club, with people enjoying a day at the pool and taking in the many activities to be found at the club and around the grounds. Food was served from the cabana area at lower right, and brightly colored umbrellas provided shade from the hot sun. The diving board was continually in use, and children had their own wading pool adjacent to the main pool.

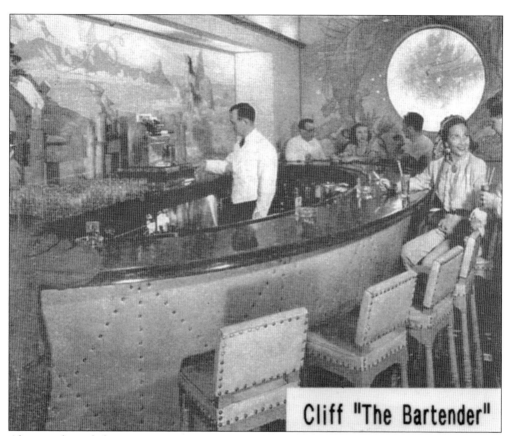

Cliff "The Bartender"

Above is the only known photograph of the well-liked Cliff, the bartender at the Desert Club. The bar was very popular with guests and locals alike. The bartenders knew a variety of drinks and remembered the favorites of many celebrities. The nautical design theme of the Desert Club carried into the bar with large portholes and motifs of fish painted on the walls, giving the bar and adjoining outside areas the feel of a tropical tiki bar. Wooden net floats, such as the ones shown at right, adorned parts of the bar and were later salvaged from the Desert Club.

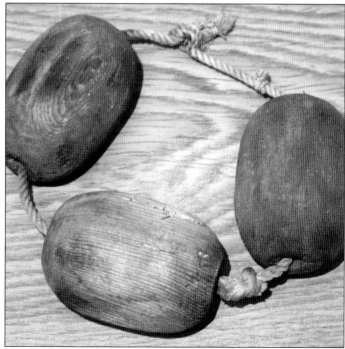

Pictured is a partial orange and brown floor tile from the Desert Club after it was completely rebuilt from a fire in 1965. The new Desert Club was rebuilt with a Spanish Revival motif and was more family-oriented into the 1970s. Ownership changed frequently, and continued financial problems coupled with mismanagement led to declining numbers and its closure in the mid-1980s.

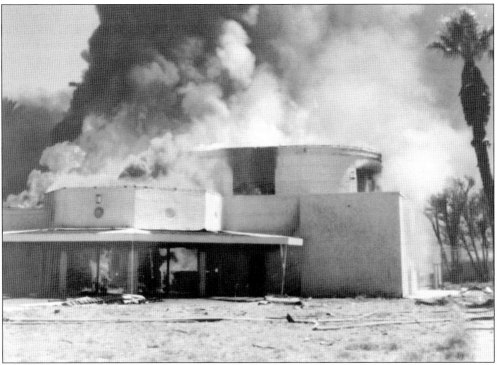

Pictured is the burning of the abandoned Desert Club in 1989. The Riverside County Fire Department used the building as practice for structure fires and was on site for several days until the structure and grounds were completely demolished, with only memories left.

Seven

HARD TIMES

The Great Depression was underway. Prohibition had ended, and Harry Kiener started a new venture, the La Quinta Milling and Lumber Company, to develop the village for Cove commercial needs. The focus was around a six-sided park. The structures were to emulate the La Quinta Hotel in the Spanish Colonial Revival style. The buildings were completed in 1936, while casitas were continuing to be built throughout the Cove.

The La Quinta Hotel acquired new owners after Walter Morgan's death and was as popular as ever. Celebrities continued to flock to the hotel for seclusion and a measure of privacy.

The Desert Club opened on Thanksgiving Day 1937 and was off to a good start. John Barrymore was in town at a guest residence behind the two-story milling office in the late 1930s before his last film, *Playmates*, in 1941.

Agriculture was booming due to electrical pumps for irrigation. Ranchers were increasingly attracted to the area, and date and citrus groves reigned supreme. Hoover Dam and the All-American Canal were under construction to bring more water to the arid West.

December 7, 1941, brought an attack on Pearl Harbor and, with it, the closure of the La Quinta Hotel in the spring of 1942 for the duration of the war. The golf course withered and died as the US government requisitioned the property. Local youth enlisted and were sent to nearby Camp Young.

Building ceased as materials went to the war effort. Hollywood was war bound, and the Desert Club grew quiet as gas rationing, victory gardens, and war bond drives replaced the tourist trade.

After the war, Frank Capra and Joel McCrea returned and resurrected interest in the La Quinta Hotel. Legendary Hollywood director Dorothy Arzner moved to La Quinta, and Garbo was back visiting the hotel. Building throughout the area resumed, and agriculture blossomed once again. It was time to write *It's a Wonderful Life*.

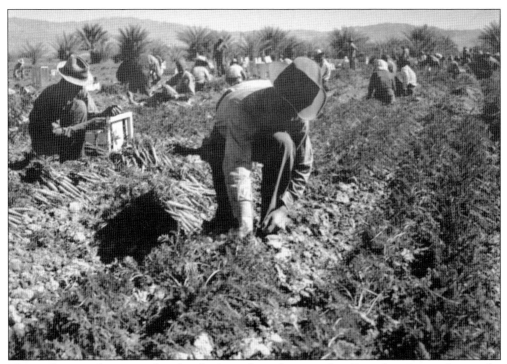

These photographs were taken by the legendary photographer Dorothea Lange during the Depression. She was hired by the photographic unit of the Farm Security Administration in the 1930s to document migratory farm labor camps and workers. She spent time in the Coachella Valley and took photographs of carrot pullers in the fields working on the east side of the valley, including around the La Quinta area. Wages for the laborers were less than $1 a day. The Farm Security Administration office was in Indio at the time. Date groves and the Santa Rosa Mountains are in the background. The photographs are dated 1937. (Both, courtesy of the Library of Congress.)

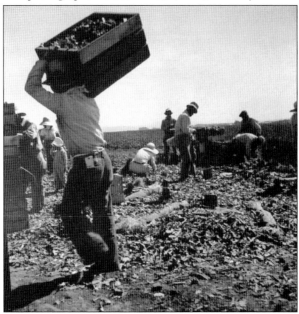

Pictured are the original La Quinta Milling and Lumber Company building (above) and sales administration office (below), for rentals and sales of houses and lots. Stables were initially behind the milling and lumber office. The properties have changed hands many times and were used for a variety of uses, including a mutual water company, real estate offices, and rented living space. The sales administration office building, a hexagonal-shaped structure, was home to the La Quinta Historical Society Museum for many years prior to the opening of a new museum by the City of La Quinta in 2008. The new museum retained the unique building, and it currently houses the office of the La Quinta Historical Society.

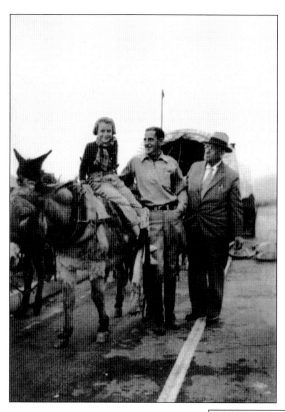

Actor John Barrymore (center) is pictured here with his attending physician and a young friend. Barrymore was sent to La Quinta for rest before his 1941 film *Playmates*, due to poor health. He stayed at a guest house behind the La Quinta Milling and Lumber Company office under close surveillance and was not allowed to drink, drive, or carry cash. He died the following year.

Young adventurers Louise Rodarte (right) and a friend try their hand at early automobile driving. Rodarte was born and raised at Point Happy Date Gardens and attended Point Happy Elementary School. Most roads were still unpaved or dirt at the time. Tires were fragile, often subject to puncture on the bumpy desert roads. There were no airbags, seat belts, or roll bars in open touring cars of the day. Speed limits were unknown.

Pictured are trucks hauling Zerolene, a product of the Standard Oil Company that was manufactured starting in 1907 and used in engines as a lubricating oil, especially in Ford Model Ts to reduce "chattering" in the engine, along with boosting performance. It was considered the best motor oil, as it flowed at zero degrees Fahrenheit, hence the name, and was popular throughout the 1910s–1950s. Zerolene could be bought in bulk as well as in smaller amounts. Bulk deliveries were good for ranchers and farmers, as trucks came to dispense amounts needed on demand. The smaller cans on the truck at right were for dispensing smaller quantities. The sight of Zerolene trucks would have been common in the La Quinta and Santa Rosa Cove areas in the early 1900s as automobiles became increasingly popular and the use of agricultural machinery was growing.

Gen. George S. Patton was in charge of the 3rd Armored Division, stationed in Europe in World War II, and used Camp Young near Desert Center, California, for training close to a million soldiers for desert warfare. Patton frequented the Desert Club in La Quinta during the war years, and some of his commanding officers were rumored to have stayed at the La Quinta Hotel.

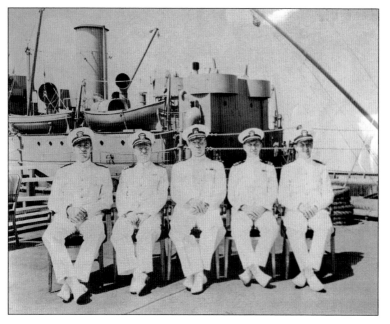

Dr. Harner, a part-time casita resident of La Quinta, was called to serve as a senior medical officer during World War II. He is pictured second from left with medical colleagues in September 1942.

Jess Rodarte, brother of Louise (Rodarte) Neeley and sister Josephine, is seen here at age 26 when he enlisted in the US Army and trained at Camp Young under General Patton. He served from July 10, 1941, to October 16, 1945, in Leyte Gulf, Attu, Kiska, Kwajalein, and Okinawa. Many enlisted men and women from the area returned with distinguished service records.

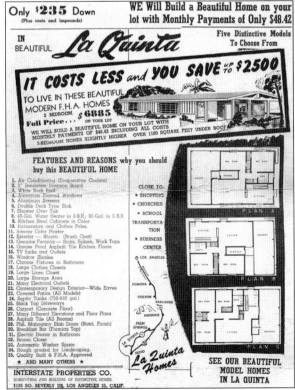

Veterans sought quiet locations and a return to normalcy after the war. Many had trained at Camp Young and remembered leaves to La Quinta and the Santa Rosa Mountains. Sales brochures highlighted the area, promoting 1,100-square-foot homes with the latest amenities. Homes could be purchased for $6,885 from a choice of five models. Monthly payments as low as $48.42 helped fuel sales.

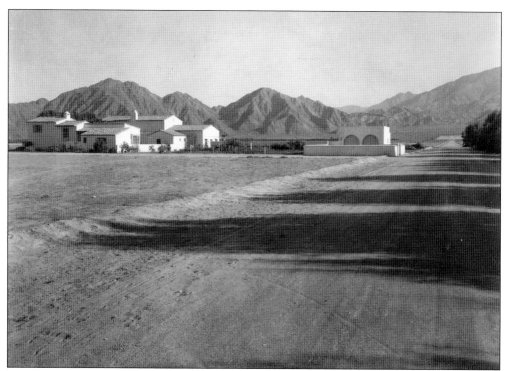

The La Casa estate was designed by architect Gordon B. Kaufman in the 1920s and was the home of Lee Eleanor Graham, who referred to it as Casa Magnolia. Kaufman incorporated several design elements, such as varying roof elevations, to help disperse heat. The walls are adobe bricks covered by plaster, made locally. Originally bordering the La Quinta Hotel, it is now part of the hotel's holdings, as is property once owned by actor Richard Widmark across from La Casa.

Film director Dorothy Arzner's residence was also close to La Casa. As Hollywood's first female director, Arzner was a major catalyst, directing 17 films from 1927 to 1943. She also created training films for the Women's Army Corps during World War II. She retired in 1943, relocating to La Quinta in 1951, where she often commented in correspondence on her 50 or more rose bushes. She remained in La Quinta until her death in 1979, whereupon her residence became part of the La Quinta Hotel holdings. (Courtesy of the British Film Institute.)

Eight

WATERWAYS AND FAIRWAYS

La Quinta was growing. Agriculture was booming, but more agriculture meant greater demand on the aquifer under the valley. Construction of the Coachella Branch of the All-American Canal, completed in 1948, eventually provided supplemental water to crops and citrus and date groves. World War I–era water pipes in need of repair would have to wait until La Quinta incorporated for upgrades.

Brothers Leon and Mark Kennedy arrived in 1947 and built the Kennedy Brothers Ranch into a 2,200-acre agricultural powerhouse where PGA West now resides.

The chamber of commerce formed in 1950, and the La Quinta Volunteer Fire Department was chartered in 1952, with the Fire Belles Auxiliary, La Quinta Garden Club, Soroptimists, and Rotary to follow.

Louie L'Amour was scouting Western venues around 1953 in Rancho La Quinta and the Santa Rosa Mountains, and Hollywood celebrities were back frequenting the La Quinta Hotel. Ginger Rogers and Jacques Bergerac wed at the fountain in 1953.

In 1958, Leonard Ettleson, along with other charter members, bought the La Quinta Hotel and 1,000 acres around it. They filed articles of incorporation with Riverside County in 1959 and built La Quinta Country Club. The golf course was designed by brothers Frank and Lawrence Hughes. Frank was a golf course architect and agronomist. Pres. Dwight D. Eisenhower was invited to cut the ribbon at the dedication of the new 18-hole course in 1960. Golf and tennis were back, including tennis legends Alice Marble and Ellsworth Vines. Frank Capra bought a residence near the 10th fairway, as did other celebrities along the various fairways.

La Quinta Country Club hosted the first CBS Match Play Classic in 1963 and the Bob Hope Desert Classic for the first time in 1967.

In the mid-1950s, William Dupont Jr. bought the former Point Happy Date Gardens and built a new home and another close by for friend Alice Marble, while in 1961, Howard F. Ahmanson of the Home Savings and Loan Association purchased the land Albert P. Green homesteaded in 1902. He created a working ranch called Xochimilcho, complete with Toltec statuary design elements, Hereford cattle, and a nine-hole Robert Trent Jones–designed golf course, now SilverRock Resort.

Hollywood producers attracted to the area filmed scenes for *The Big Fisherman* (1959), starring Howard Keel, at Fisherman's Rock at the top of the Cove, while *The Satan Bug* (1965), starring Richard Basehart and Anne Francis, was also filmed in the La Quinta area.

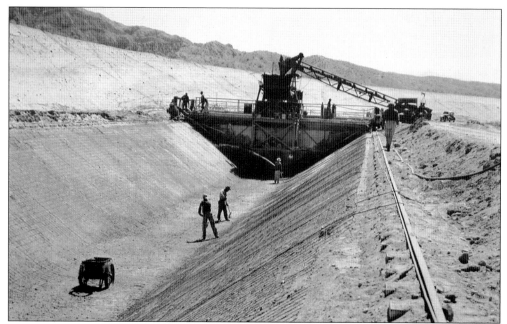

Pictured are the All-American Canal under construction around 1934 (above) and the 123-mile Coachella Branch extension completed in 1948 (below). Water flowed from the Coachella Branch Extension starting in 1949, but it would take six more years, until 1954, to complete an underground water distribution system delivering water to farms across the Coachella Valley. Agriculture boomed. Acreage increased to grow a variety of crops, including alfalfa, cotton, cantaloupes, grapes, and citrus, along with the ever-popular date groves, with many ranches in the area reporting record profits. Crop income soared to $480 per acre in 1954 from a previous $154 per acre in 1940. (Both, courtesy of the Coachella Valley Water District.)

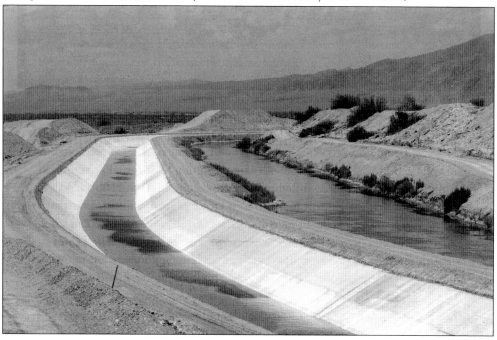

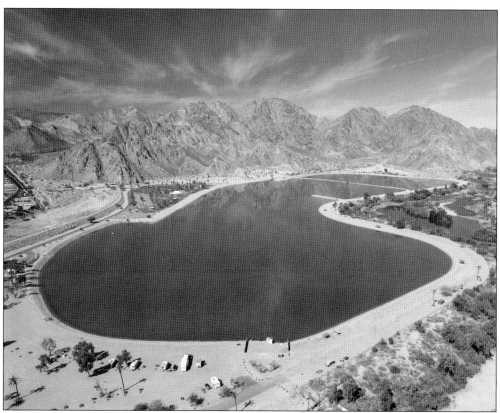

Pictured is Lake Cahuilla Reservoir at the terminus of the Coachella Branch Extension of the All-American Canal in La Quinta. The soil concrete–lined reservoir was completed in 1969 for the Coachella Valley Water District and serves dual purposes: reclamation of Colorado River water for irrigation and recreational use. It was considered the largest soil-cement reservoir in the world when completed. (Courtesy of the Coachella Valley Water District.)

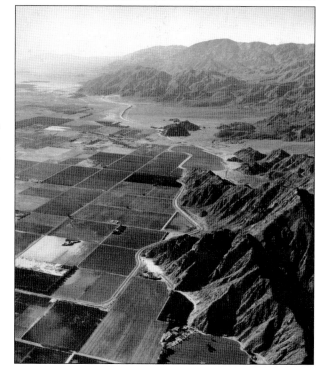

This is an aerial view of the Coachella Branch extension of the All-American Canal flowing along the farms and ranches near the Santa Rosa Mountains. The Lake Cahuilla Reservoir is at right center.

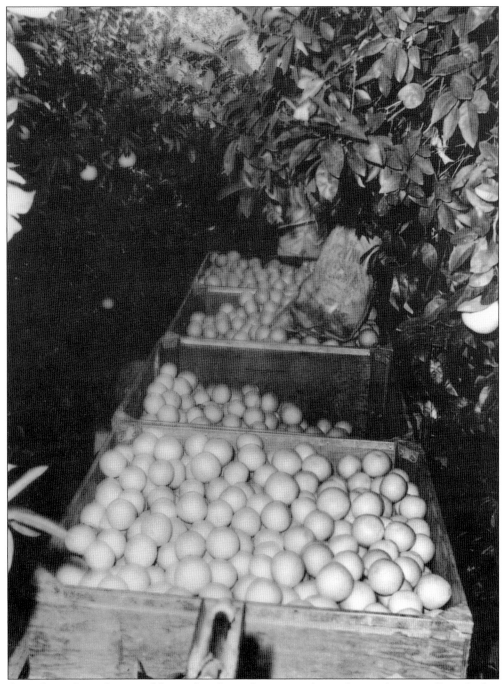

Grapefruit is being harvested for market. Several varieties of grapefruit and oranges flourished in the desert soils in and around the La Quinta area ranches from the 1910s to the 1960s. Orchards and groves have been largely replaced by residential and golf course development over the years.

No. 32

Membership Certificate
NONTRANSFERABLE

La Quinta Chamber of Commerce

A NON-PROFIT CORPORATION
INCORPORATED UNDER THE LAWS OF
THE STATE OF CALIFORNIA

THIS CERTIFIES THAT *Dr. Henry M. Weber* IS THE RECORD HOLDER
OF A MEMBERSHIP CERTIFICATE IN

La Quinta Chamber of Commerce

WITH ALL THE RIGHTS AND PRIVILEGES AND SUBJECT TO ALL THE CONDITIONS AND LIMITATIONS SET FORTH IN THE
ARTICLES OF INCORPORATION AND THE BY-LAWS.

WITNESS, THE SEAL OF THE CORPORATION AND THE SIGNATURES OF ITS DULY AUTHORIZED OFFICERS.

DATED *April 29, 1950*

Frances Hack
SECRETARY

Col. Walter C. Bowman
PRESIDENT

This membership certificate was signed by new member Dr. Weber, No. 32, in 1950 for the La Quinta Chamber of Commerce. The chamber was formed in 1950, and for many years served as the backbone of the La Quinta community, helping to support growing commercial and agricultural businesses in the community. The card was co-signed by Walter Bowman and Frances Hack, first president and secretary, respectively, of the La Quinta chamber, which they led the formation of in 1950. Hack (1899–1990) relocated to La Quinta in 1947. She was a retired talent scout who acknowledged she was the one who "discovered" Shirley Temple many years before. She turned into an influential real estate broker and benefactor in the community, with her office in the hexagonal casita that later transformed into the La Quinta Historical Society Museum. She was also influential in the acquisition of the La Quinta Community Park for the local recreation district.

The station house for the La Quinta Volunteer Fire Department is seen here. The department was originally chartered in 1952 by two US Forest Service men and six volunteers. The first volunteers relied on donations from the community for equipment needs and tools. The Keck Foundation donated their first squad truck.

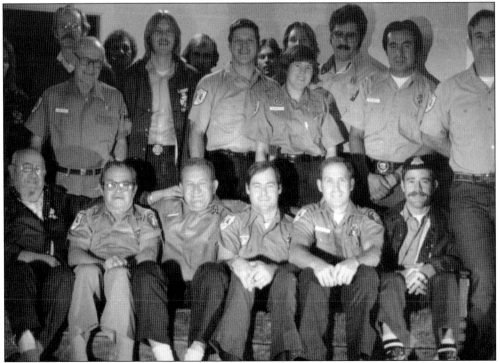

Some time later, 19 volunteer fire personnel are pictured. With the community growing and the fire station responding to more and more calls, additional volunteers stepped up to fill the need.

Pictured is a new fire and rescue truck for the volunteer fire department around 1970, with the Santa Rosa Mountains in the background. The truck became a familiar sight around the community for many years. In 1977, records showed over 352 incidents responded to in a six-month timeframe.

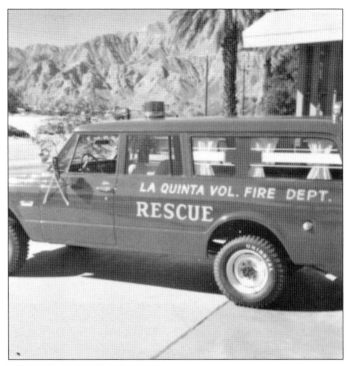

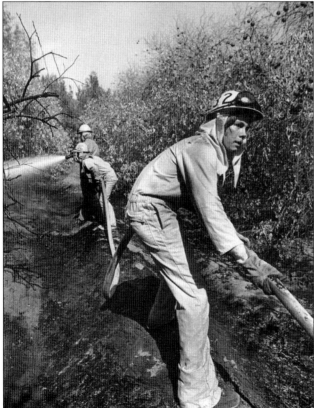

Volunteer fire fighters were trained in fighting both urban structure fires and wildfires and would have numerous opportunities to fight fires in both environments. Several thank-you letters and notes were received over the years for responding quickly to fire-related and health and wellness calls.

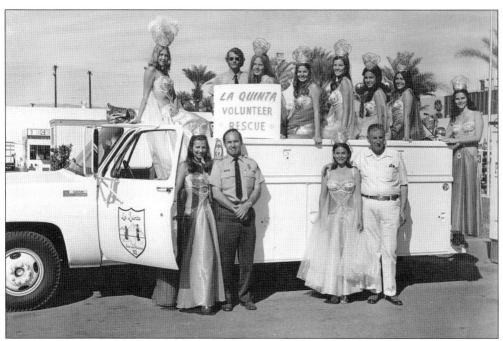

Pictured above are La Quinta Volunteer Fire and Rescue personnel with the queen's court at the Indio Date Festival around 1965. The photograph below shows Smokey Bear, the award winners for Miss Fire Control, and more. By this time, the squad's title had expanded to include "Rescue," as it responded to a number of calls associated with health and wellness as well as fire-related events. Such events, along with fundraisers, providing assistance at golf tournaments, and civic functions, promoted goodwill and a heightened awareness of the department. It also hosted annual Thanksgiving and holiday giveaways, Easter egg hunts, and numerous educational visits to local schools.

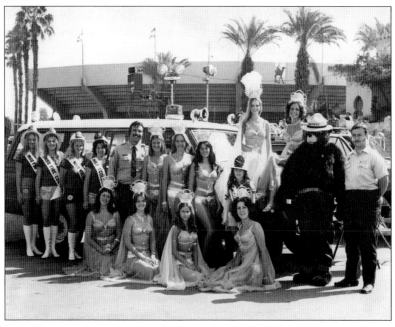

Santa makes an appearance via a firetruck on top of a stack of hoses in this c. 1965 photograph. The children of the community, as well as neighboring areas, could attend every holiday season and pitch their wish lists while parents looked on.

LA QUINTA FIRE BELLES

IE OVEN RACK JOCKEY

NO MORE BURNED FINGERS
PUSHES & PULLS OVEN RACKS WITH EASE
LIFTS LIDS - ADJUSTS GRILL - ALSO A RULER

Pictured are the front and back of a wooden ruler the La Quinta Fire Belles Auxiliary sold as a fundraiser. The reverse had instructions on how to use the ruler as an oven rack jockey to remove hot items from the oven. An ingenious concept, many rulers were sold over the years by the Fire Belles, with the money raised donated to the La Quinta Volunteer Fire Department for needed equipment and the firemen's widow fund. The group was extremely popular in the community and held a well-attended annual fashion show.

This ribbon was presented by the California Garden Club to the La Quinta Garden Club at one of its annual meetings. The La Quinta Garden Club was very popular in the community. The group held annual flower shows and Arbor Day events and also attended district flower meetings and competitions. It held various fundraisers and donated money to local charities. The group was in existence for over 25 years and disbanded in the 1990s due to aging members and a decline in membership.

This is the area that would become the Kennedy Brothers Ranch, a large agricultural enterprise over 2,200 acres run by the Kennedy brothers, Leon and Mark. Leon was also the district president of the Coachella Valley Water District from 1954 to 1976 and an influential civic leader, including being a member of the Riverside County sheriff's mounted posse. Many dignitaries and celebrities frequented the Kennedy Brothers Ranch when they were in town. The ranch grew traditional and experimental crops in the desert during the 1950s and 1960s, including cotton and peanuts. It was sold in the late 1970s and became PGA West.

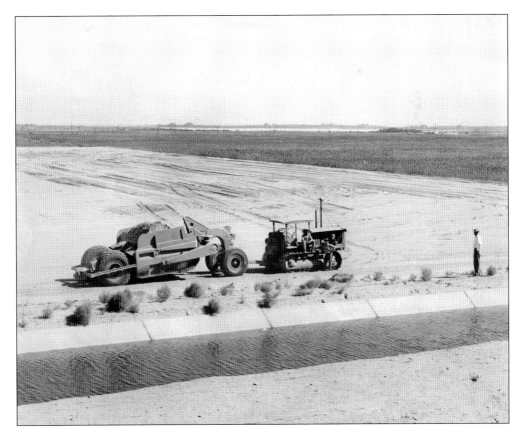

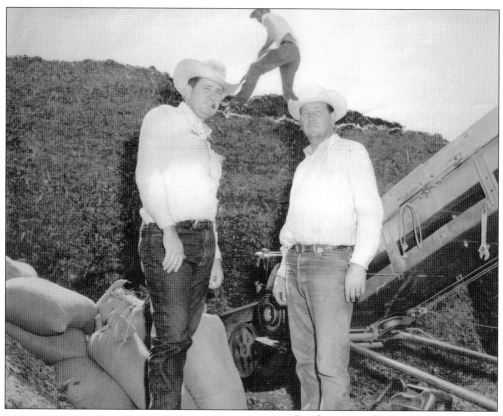

Brothers Leon (left) and Mark Kennedy are pictured at the Kennedy Brothers Ranch. They appear to be relaxing for a moment next to burlap bags being filled with alfalfa or fodder. The brothers arrived in 1947 and would make the Kennedy Brothers Ranch name well-known throughout the region and state, especially for their cotton crops.

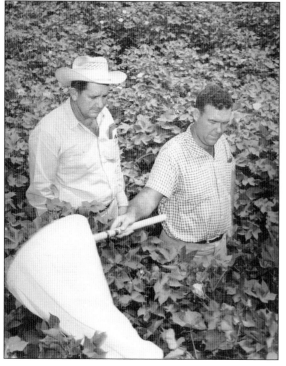

Leon Kennedy (left) is waist-deep in a field of cotton with an agricultural inspector looking for insects that attack cotton and can destroy a crop. The Kennedy brothers pioneered many techniques for growing cotton with extraordinarily high fiber.

Free-range cattle grazing is pictured here. Such grazing was one part of the Kennedy Brothers Ranch enterprise in the early days. The K-B brand, a symbol of pride and ownership for the ranch passed down through generations of Kennedy owners, also allowed for the identification of stock if different herds mingled on the free range.

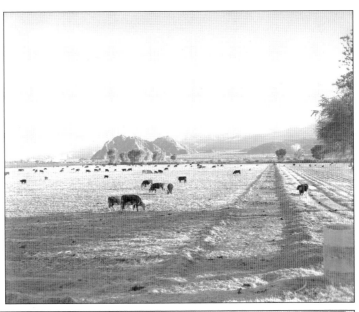

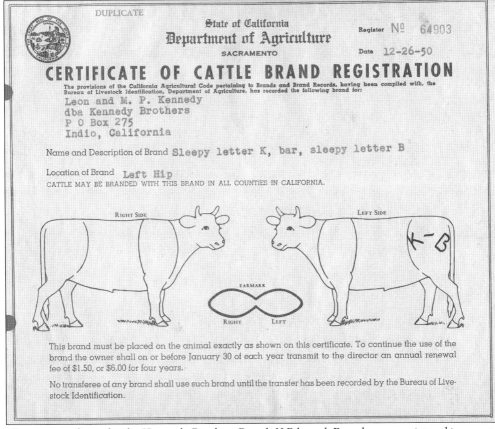

This is a certificate for the Kennedy Brothers Ranch K-B brand. Brands were registered in county and state departments of agriculture. If a letter leaned to one side or the other, it was called a "sleepy" letter. The Kennedy Brothers Ranch brand was a sleepy K-B.

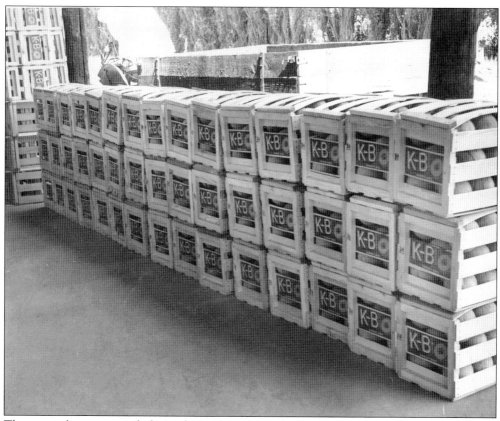

These cantaloupes are ready for market with crates displaying the K-B brand. Cantaloupes, part of the melon family, were just one of the many crops the Kennedy Brothers Ranch grew throughout the year. At one time, the Coachella Valley was the biggest producer of cantaloupes in the nation.

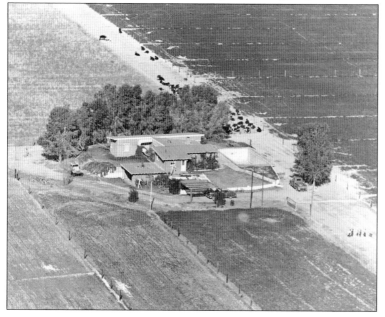

The Leon and Margaret (Marlowe) Kennedy home is shown in this mid-1950s aerial photograph. It was a large, multiroom residence surrounded by cattle and crops at the intersection of Avenue 54 and Jefferson Street.

Ropin' and ridin' was the order of the day for a young Tom Kennedy (right), age four, and visiting cousin Glen on the Kennedy Brothers Ranch.

A few years later, around age six, Tom Kennedy stops by to oversee operations at the Kennedy Brothers Ranch. Tom was the son of Leon and Marlowe Kennedy. He became a businessman and stained-glass artist in the Coachella Valley. His work can be seen at various places in the desert, most notably the charming stained-glass windows of Lord Fletcher's Restaurant in Rancho Mirage, California.

Margaret Kennedy, more commonly known as "Marlowe," is enjoying a ride with daughters Marlo (left) and Sue through the ranch on a modified Cushman scooter in June 1960.

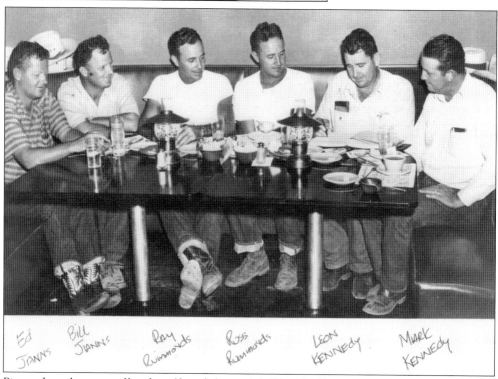

Ed Janns Bill Janns Ray Rummonds Ross Rummonds Leon Kennedy Mark Kennedy

Pictured are three sets of brothers (from left to right), Ed and Bill Janns, Ray and Ross Rummonds, and Leon and Mark Kennedy. They would often meet to discuss crops and ranching trends, along with opportunities to improve agricultural methods or to catch up on the latest news regarding market prices, family, and friends.

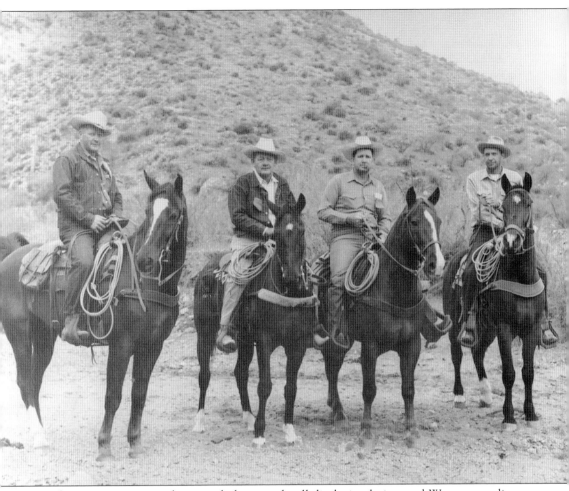

Four horsemen appear in this staged photograph, all displaying lariats and Western regalia as portrayed in early TV Westerns like the popular series *Bonanza*. The horses appear to be quarter horses, which were commonly seen on working cattle ranches, such as the Kennedy Brothers Ranch, due to their ability to cut and rein quickly. Leon Kennedy was an exceptional horseman and enjoyed riding whenever he could, especially his favorite horse, Palomas. He also rode in parades as part of the Riverside County sheriff's mounted posse. According to the back of the photograph, pictured are Rudy Heilmark, Phil, Leon Kennedy (third from left), and Doc Hatch.

Pres. Dwight D. Eisenhower visits with Mark Kennedy and actor Chuck Connors of *The Rifleman* fame at the Kennedy Brothers Ranch. Both Eisenhower and Connors visited the ranch frequently, as did a number of other dignitaries and celebrities.

Tina Kennedy, wife of Mark Kennedy, visits with Mamie Eisenhower (President Eisenhower's wife), and famed aviatrix Jacqueline Cochran at the Kennedy Brothers Ranch. Cochran owned an 800-acre ranch in nearby Indio, now called Indian Palms Country Club, which she frequented.

La Quinta Hotel manager Steen Weinold (far left) and charter members Ed Crowley (second from left) and Leonard Ettleson (center) are pictured along with other dignitaries breaking ground for the new La Quinta Country Club in late 1958. It would take a year under the direction of noted golf course architect Lawrence M. Hughes to bring the course to life, with opening day on November 14, 1959. A year later, on October 23, 1960, President Eisenhower officially dedicated the $500,000 La Quinta Country Club 18-hole championship golf course.

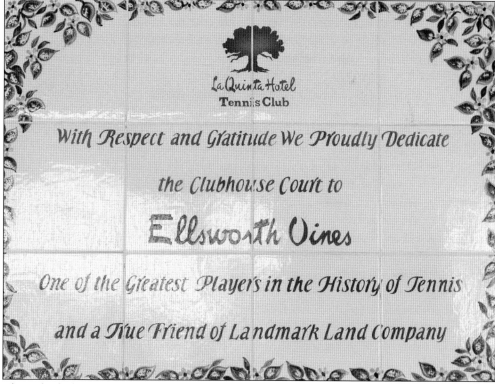

This inlaid tiled marker at the La Quinta Hotel dedicates the Clubhouse Court to tennis great Ellsworth Vines. In the 1940s, he switched to golf and won a number of professional titles. He came to La Quinta Country Club in 1963 as the director of golf and tennis. He promoted the club tirelessly and grew the membership substantially.

La Quinta Country Club charter member Leonard Ettleson (left) and professional golfer Jimmy Demaret chat on the La Quinta Country Club grounds. Demaret won 31 PGA Tour events in a long career between 1935 and 1957 and was the first three-time winner of the Masters, with titles in 1940, 1947, and 1950. He hosted the first CBS Match Play Classic Tournament, which was held at the club in 1963.

From left to right are Ellsworth Vines, Ed Crowley, Gene Littler, and two unidentified dignitaries standing at the leader board during the CBS Match Play Classic Tournament in 1963.

Jimmy Demaret (center), host of the CBS Match Play Classic Tournament, introduces (from left to right) Jerry Barber, Jack Nicklaus, Gary Player, and Gene Littler before the tournament begins. Littler would go on to win the tournament and garner much attention for the La Quinta Country Club. Matches were played for a week and televised during the winter. CBS would repeat the event at the La Quinta Country Club in 1964. The event was retired around 1966.

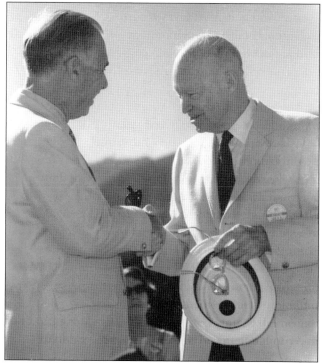

President Eisenhower, a golf aficionado, talks with Leonard Ettleson. He is sporting an "Official" button on his jacket, so he may have been officiating an event. Eisenhower's brother Edgar was a familiar presence at the La Quinta Country Club, and President Eisenhower would often visit with him while staying at the La Quinta Hotel.

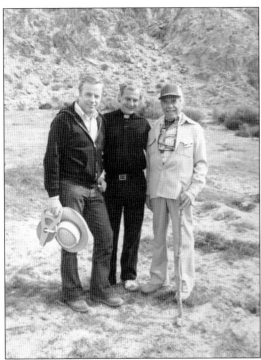

Pictured around 1982 are, from left to right, Franco Zeffirelli, Father Bluett, and Frank Capra standing on the site where the new St. Francis of Assisi Church would be built. It is on the south portion of the old Point Happy homestead on Washington Street in La Quinta and was dedicated in 1984. For the first 10 years of the parish's history, starting in 1974, there was no parish church building. Church services were held at the local Crocker Bank and Simon Motors auto dealership.

Construction is beginning at the site of the new church. It would take two years to complete. The concept and design were envisioned by film director Franco Zeffirelli and Father Bluett, the parish priest. The church is patterned after the Church of St. Francis in Assisi, Italy. The first Mass was attended by Frank Sinatra, Gregory Peck, Cary Grant, and Roger Moore.

Alexander Rosenfeld, the artist who designed and painted 14 frescoes reproducing the Giotto murals of the original Church of St. Francis in Assisi, Italy, is seen here. He was a local artist, and many came to see him work on the frescoes at the church.

This is a c. 1984 photograph of the completed St. Francis of Assisi Church. It has become a landmark in the community and a tribute to the community leaders involved in its construction.

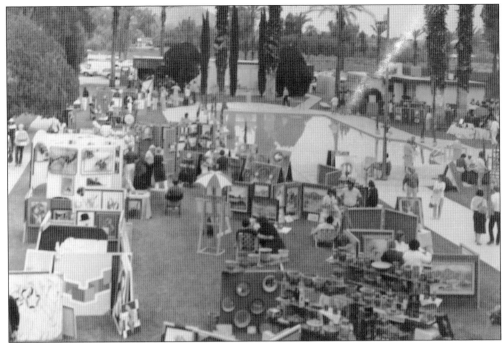

Fred Wolff, first mayor of the City of La Quinta and co-founder of the La Quinta Arts Foundation, incorporated in 1982, stated, "A city must be more than streets and buildings, cops and workers, ordinances and development. It must provide opportunity for positive participation and self-fulfillment of the individual, while contributing to the community." With that mission in mind, the inaugural festival, Celebration of the Arts, was held in 1983 on the old Desert Club grounds. The festival grew exponentially, attracting thousands over the following years before moving to a larger venue.

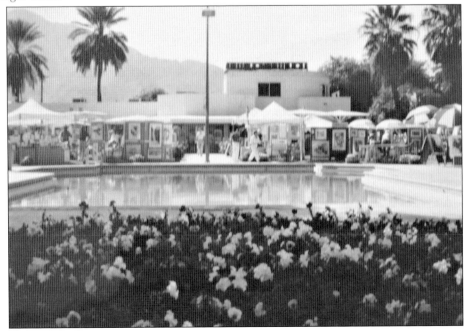

Nine

THE DRIVE FOR INCORPORATION

The local community of approximately 3,500 in 1980 needed dedicated services as the population continued to increase. Two prior attempts at incorporation had failed due to an inadequate tax base and lack of clearly defined objectives and organization. It was time for a third try.

Newly arrived in 1980, residents Fred and Kay Wolff became involved and formed task forces and committees in their living room over the next 18 months. Studies were completed, demographic data and budgets were compiled, and maps were drawn with a comprehensive approach to present to the Local Agency Formation Commission of the State of California. Teams canvassed local residents, encouraging votes for incorporation. Opposition by some local developers and businesses was overcome. Riverside County approved a vote of the people to decide on incorporation. The vote overwhelmingly carried the third time around.

May 1, 1982, arrived and, with it, the new City of La Quinta. Fred Wolff gaveled the first City Council meeting to order at the community center, officially activating the new city. He was then unanimously voted the city's first mayor. Sitting around a makeshift table at the community center with him were four newly sworn-in council members—Gene Abbott, Bob Baier, Judy Cox, and John Henderson—along with the first city employee, city manager Frank Usher.

Festivities followed at the La Quinta Hotel with county supervisor Al McCandless extending congratulations to the new city and Robert Fitch, chief administrative officer for the county, giving the official incorporation vote total.

Firefighters and civic organizations, along with pioneer families of the community and celebrities, were recognized with plaques and proclamations. A champagne reception took place at the La Quinta Hotel, followed by private parties, barbecues, and baseball games.

A patio dance on the grounds of the old Desert Club ended the day. The new city of La Quinta was on its way.

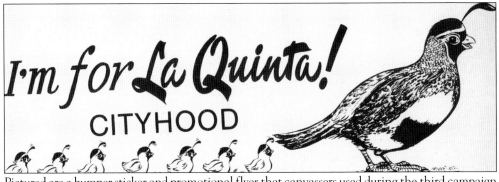

Pictured are a bumper sticker and promotional flyer that canvassers used during the third campaign to incorporate the community. Tireless efforts by teams of local residents, led by Fred and Kay Wolff, resulted in success, with an overwhelming vote on April 13, 1982, for incorporation. The quail pictured on the bumper sticker and flyer were designed by internationally known artist and illustrator Fred Rice, a local resident. The quail was also incorporated into the city seal. Rice worked on countless graphics and projects for community events and celebrations and was the second president of the La Quinta Historical Society.

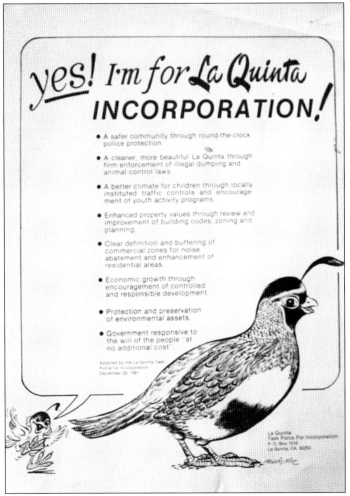

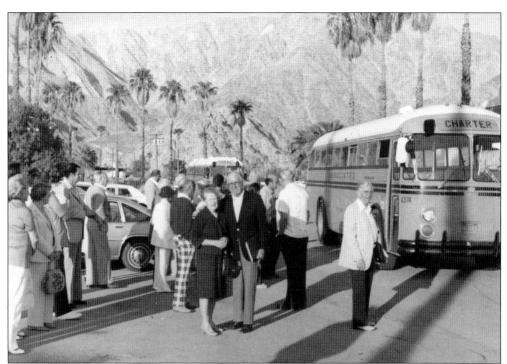

Buses await departure to deliver several La Quinta community members to the county supervisor's office in Riverside, California, where the discussion about incorporating the City of La Quinta would transpire. Two earlier attempts at incorporation had failed, but the crowd that attended was optimistic that the third time was the charm. The discussion went well, and a date for an election was set.

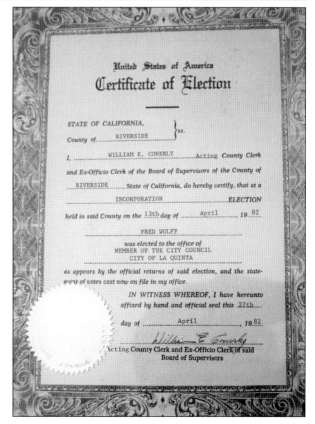

This certificate of election was presented by the county to Fred Wolff when he was elected to the city council of La Quinta. The certificate is dated April 13, 1982. Wolff went on to be unanimously elected as the first mayor at the first council meeting.

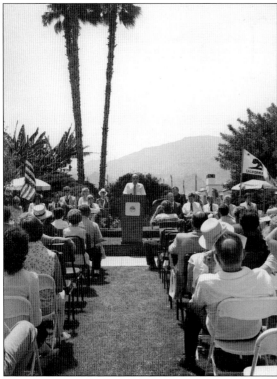

At left above are local residents Frank and Lucille Capra, followed by Fred and Kay Wolff, on their way to hear inaugural speeches on May 1, 1982. Congratulations and speeches were given by Al McCandless, Riverside County supervisor for the Fourth District, Fred Wolff, and other dignitaries. An enthusiastic crowd awaited all the speeches announcing the new city of La Quinta. California governor Edmund "Pat" Brown attended, sharing warm memories of visiting the La Quinta Hotel in years past.

Pictured is Fred Wolff addressing the assembled crowd on May 1, 1982. He told of the hard efforts undertaken by volunteers in the community, many of whom worked door-to-door to gather support for incorporation and some of the citywide projects that would be started in the coming days.

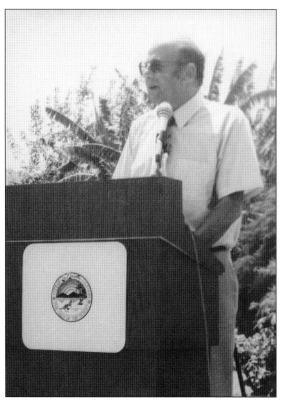

The new Fred Rice–designed city seal was on full display at the celebratory podium. La Quinta's official motto became "The Gem of the Desert," as shown on the seal. The Gambel's quail (*Lophortyx gambelii*) on the seal is La Quinta's official bird. Its official flower is the purple sand verbena (*Abronia villosa*), and its official tree is the smoke tree (*Dalea spinos*).

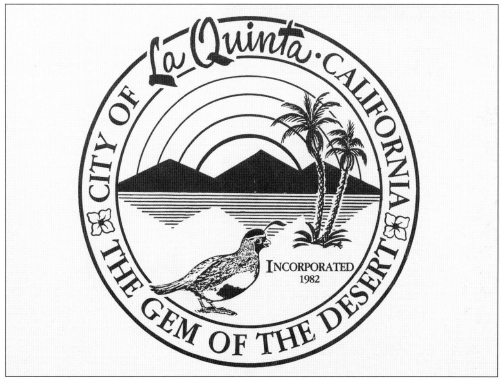

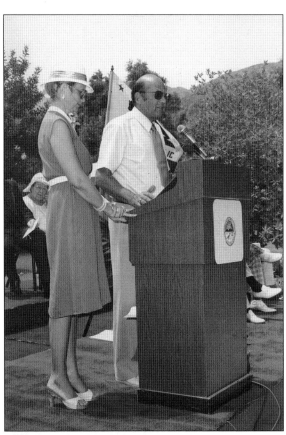

Kay Wolff joins Fred at the podium. Throughout the years, the couple would often be referred to as La Quinta's "first couple," and Kay was known as the "first lady" of La Quinta. The popular Fred Wolff Bear Creek Nature Preserve and Trail are named in his honor.

Pictured with Mayor Fred Wolff (far right) are local dignitaries (from left to right) Manny Rios (Coachella mayor), Roger Harlow (Indio mayor), Roy Wilson (Palm Desert mayor), Al McCandless (Riverside County supervisor), and Pat Murphy (Cathedral City mayor).

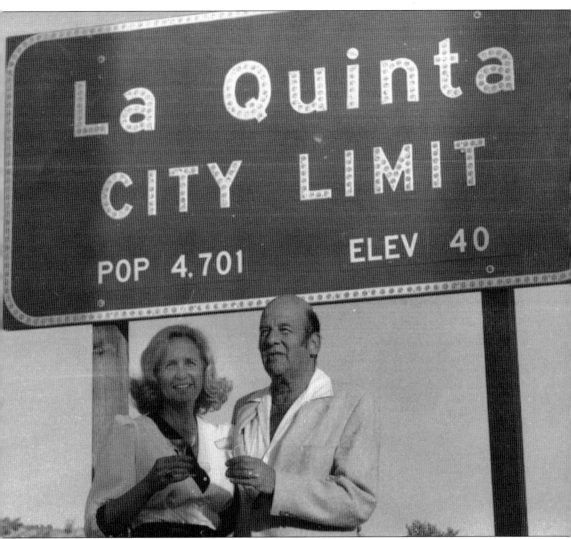

Fred and Kay Wolff stand under the first sign denoting La Quinta as a city. The photograph was taken during the day between a number of celebratory events, including the first city council meeting, Mayor Wolff throwing out the first baseball at Lynn Mowat Field, a reception at the La Quinta Hotel, and a dance at the site of the former Desert Club.

Pictured are Fred and Kay Wolff around 2000. Fred passed away on May 18, 2004, but his legacy looms large over the city he loved.

BIBLIOGRAPHY

Bean, Lowell John, and Harry Lawton. *The Cahuilla Indians of Southern California*. Banning, CA: Malki Museum Press, 1979.

Bean, Lowell John, and Katherine Siva Saubel. *Temalpakh: Cahuilla Indian Knowledge and Usage of Plants*. Banning, CA: Malki Museum, 1972.

Herz, Peggy. *La Quinta Country Club*. 1984.

Johnston, Francis J. *The Bradshaw Trail*. Riverside, CA: Historical Commission Press, 1987.

"La Quinta Cove Thematic Historic District Survey." Mellon and Associates, 1997.

Mouriquand, Leslie. "City of La Quinta Historic Context Statement." 1996.

Nordland, Ole J. *Coachella Valley's Golden Years: The Early History of the Coachella Valley County Water District and Stories about the Discovery and Development of This Section of the Colorado Desert*. Coachella, CA: 1978.

Quinn, Harry M. *Observations on the Cahuilla Indians—Past and Present*. Coachella Valley Archeological Society, 1997.

Wilke, Philip J. *Late Prehistoric Human Ecology at Lake Cahuilla, Coachella Valley, California*. Berkeley, CA: University of California Department of Anthropology, 1978.

Young, Patricia Mastick. *History of Coachella Valley's Cove Communities*. Palm Desert Historical Society.

DISCOVER THOUSANDS OF LOCAL HISTORY BOOKS FEATURING MILLIONS OF VINTAGE IMAGES

Arcadia Publishing, the leading local history publisher in the United States, is committed to making history accessible and meaningful through publishing books that celebrate and preserve the heritage of America's people and places.

Find more books like this at
www.arcadiapublishing.com

Search for your hometown history, your old stomping grounds, and even your favorite sports team.

Consistent with our mission to preserve history on a local level, this book was printed in South Carolina on American-made paper and manufactured entirely in the United States. Products carrying the accredited Forest Stewardship Council (FSC) label are printed on 100 percent FSC-certified paper.

MADE IN THE USA